IMAGES
of Aviation

SAN FRANCISCO
BAY AREA
AVIATION

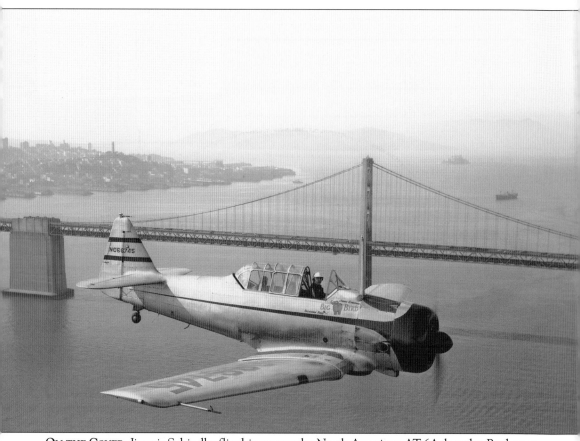

ON THE COVER: Jimmie Schindler flies his war-surplus North American AT-6A, based at Buchanan Field in Concord, alongside the San Francisco–Oakland Bay Bridge on February 23, 1947. The Coit Tower and the Golden Gate Bridge can be seen on the left. The passenger in the back seat is the yet-to-be-famous oceanographer and deep-sea diver Don Walsh. (WL.)

IMAGES
of Aviation

SAN FRANCISCO
BAY AREA
AVIATION

William T. Larkins and
Ronald T. Reuther

ARCADIA
PUBLISHING

Published by Arcadia Publishing
Charleston SC, Chicago IL, Portsmouth NH, San Francisco CA

Printed in the United States of America

Library of Congress Catalog Card Number: 2006938513

For all general information contact Arcadia Publishing at:
Telephone 843-853-2070
Fax 843-853-0044
E-mail sales@arcadiapublishing.com
For customer service and orders:
Toll-Free 1-888-313-2665

Visit us on the Internet at www.arcadiapublishing.com

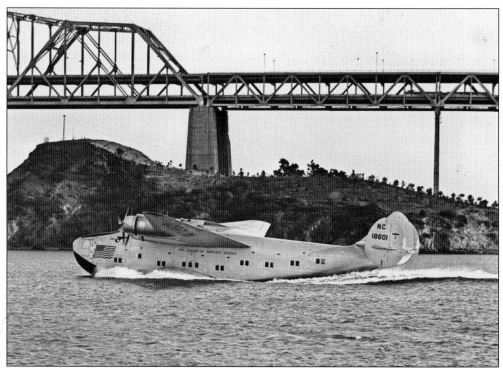

Pan American Airways Boeing 314A, NC-18601 is pictured in the lagoon at Treasure Island in 1940. It is leaving to taxi out into the bay for takeoff to fly to Hawaii. A portion of Yerba Buena Island and the San Francisco–Oakland Bay Bridge are in the background. Pan American Airways operated regular airline service during the fair so visitors were able to watch the entire operation. Water flying has been continuous in the area for over 95 years with floatplanes, amphibians, and flying boats operated by airlines, private owners, the U.S. Navy, and the Coast Guard. (WL.)

CONTENTS

Acknowledgments 6

Introduction 7

1. The Early Years 9

2. The Roaring Twenties 15

3. The Golden Years 33

4. Expansion and Development 57

5. World War II 79

6. Postwar and the Jet Age 93

ACKNOWLEDGMENTS

We wish to thank all of the individuals who have contributed information over the years, in particular, Kenneth Bourke, Peter Bowers, Howard Campbell, Douglas Olson, and the staff at the Western Aerospace Museum.

Individual photograph credits are as follows:

DC Dave Caruso
LC Larkins Collection
OC Olson Collection
PB Peter Bowers
RC Reuther Collection
WAM Western Aerospace Museum
WL William Larkins

INTRODUCTION

This is a discussion of the history of aviation in the San Francisco Bay Area of Northern California. For the purposes of defining that geographic region we are using the official area of the Association of Bay Area Governments (ABAG), which is composed of the following counties: Alameda, Contra Costa, San Francisco, Santa Clara, San Mateo, Solano, Sonoma, and Marin.

There is a significant aviation heritage in this area that has not been well documented. This book is only a brief look at some of the things that have been seen in the area. A complete history of all of the people, events, aircraft, and over 50 airfields would require an 800-page book. In addition, this book ends with the year 1968, so, as of this writing, 38 more years already have passed into history. The Bay Area has seen the end of naval-reserve flying that started in 1928, the closing of Hamilton Field, Moffett Field, and Naval Air Station Alameda as well as a large increase in airline traffic and airport expansion. San Francisco, Oakland, and San Jose are now international airports.

In the early days of aviation, even though there were some major contributors to the field in this area, those who were contributing to the field in the more established Eastern and Midwestern United States and who were closer to the bulk of the national population, major media, money, and major cities, tended to become known, supported, and recorded for posterity. Out West, institutions were few and embryonic. There were fewer people, fewer media, and less money and communications, and as a consequence, the western pioneers and their efforts were less known and recorded.

In the case of Oakland and Alameda airports and elsewhere in the Bay Area, events that happened at these locations were often mistakenly included in publications and references as being or having happened in San Francisco. The general public and even historians tend to lump all cities in the Bay Area under the name San Francisco because it is the region's biggest city and its geographic identifier and reference point.

Another source of confusion is the fact that a number of commercial airlines, military operations, and private operators relocated from time to time, sometimes with only brief intervals, on various Bay Area airfields, and some of them had two or more operations at two or more fields at the same time. Thus this book is an attempt to review the region's aviation history, fill in some gaps, record it, and present it in an accurate, interesting way so that the significant efforts and activities of San Francisco Bay aviation people and events will become better known and its history more complete.

Many early aviators were first involved with automobiles and automobile racing. An interest in mechanical things, motors, and faster means of getting from one point to another motivated these pioneers to take up aviation. Major events in the San Francisco Bay area affecting aviation development have been the big earthquake in 1906, which probably significantly slowed early experiments, especially by John J. Montgomery and Capt. Thomas Baldwin; and World War I and World War II, both of which significantly advanced aviation. During both wars, there was a

huge increase in training of aviation specialists, of bases built, of aircraft and engines built, and in the advance of knowledge, design, engineering, and technology.

Northern California facilities that have had a large impact on aviation have been NASA Ames Research Laboratory (research); San Jose State, University of California, Berkeley, and Stanford University (research and education); Alameda Naval Air Station, Moffett Field, Crissy Field, and Travis AFB (military operations); and Oakland and San Francisco Airports (operations at both; training and innovation at Oakland).

The main style of the book has been generally to follow the history chronologically, but in many cases, we have interrupted the chronology to elaborate on some of the detail and history of individuals, companies, and events. We hope this style will satisfy most of the readers and make the book more interesting.

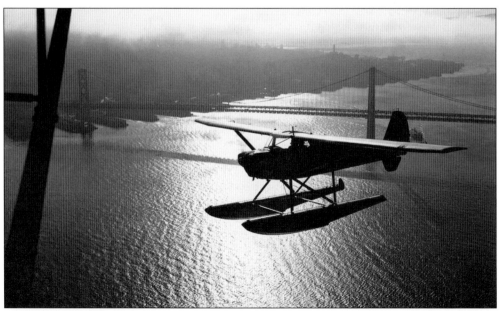

The tranquil beauty and pleasure of flight around San Francisco Bay is exemplified by this photograph from another era. (WL.)

One

THE EARLY YEARS

In the fall of 1999, *USA Today* and the Newseum, an Arlington, Virginia, museum devoted to the history of news gathering, announced the results of a yearlong poll in which 36,000 newspaper readers and a substantial number of journalists were asked to select the 100 most important news stories of the 20th century. The atomic bombing of Japan led the public list, followed by the attack on Pearl Harbor, the landing on the moon, and the invention of the airplane. Almost no one seems to have noted the fact that the top three stories could not have occurred without the invention of the airplane.

During the mid-1800s, the population of California and the San Francisco Bay Area was small, and industry and transportation was relatively poorly developed compared with Europe and the northeastern United States. As a consequence, those in the western United States interested in aviation were at some disadvantage from those who lived in more developed areas. Nonetheless, some western inventors and experimenters accomplished significant achievements, using balloons, gliders, and powered blimps.

Wilbur and Orville Wright, printers and bicycle builders from Dayton, Ohio, took their first serious step toward the invention of the airplane in 1899. The brothers made the first four sustained, powered flights under the control of the pilot near Kitty Hawk, North Carolina, on the morning of December 17, 1903. Over the next two years, they continued their work in a pasture near Dayton, Ohio. By the fall of 1905, they had achieved their goal of constructing a practical flying machine capable of remaining in the air for extended periods of time and operating under the full control of the pilot. The air age had begun. Unwilling to unveil their technology without the protection of a patent and a contract for the sale of airplanes, the Wright brothers did not make public flights until 1908.

The invention of the airplane was a fundamental turning point in history. It redefined the way in which the world fought its wars, revolutionized travel and commerce, and fueled the process of technological change. Beyond all of that, flight remains one of the most stunning and magnificent human achievements. For millennia, the notion of taking to the sky was regarded as the very definition of the impossible. "If God had intended for human beings to fly," it was said, "he would have given us wings." Instead, we built wings for ourselves, and forever expanded our vision of the possible.

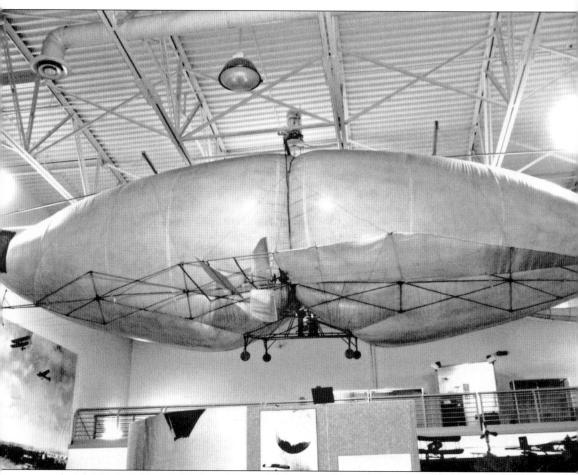

Frederick Marriott formed the Aerial Steam Navigation Company in 1866 to finance a dirigible. The *Avitor Hermes Jr.*, intended as a model for a larger airship, was completed in June 1869. The gas-filled bag, 37 feet long, was fitted with wings, elevator and rudder, and a small steam engine. On July 2, 1869, the *Avitor* flew at Millbrae. It was the first powered flight of a lighter-than-air vehicle in the western hemisphere. The photograph shows the full-size replica in the Hiller Aviation Museum. (WL.)

John J. Montgomery was born in Yuba City, California, on February 15, 1858. He and his family moved to Oakland and then to Otay Mesa near San Diego, where he designed and flew his first glider on August 28, 1883. He has been credited by some as being the "father of controlled flight" because he incorporated for the first time in history control surfaces in the wing and tail of his aircraft. He later continued his experimentation in the Bay Area, where he was a professor of engineering at Santa Clara University. (RC.)

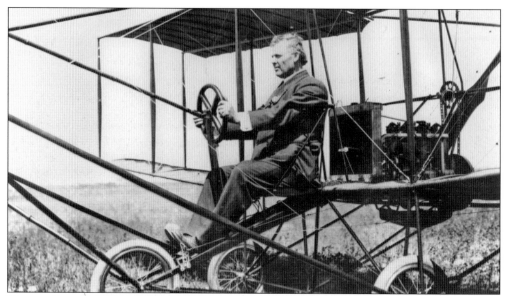

Thomas Scott Baldwin made the first parachute jump in the western United States, leaping from a balloon 3,000 feet over Golden Gate Park in San Francisco on January 30, 1897. On August 3, 1904, at Oakland, the *California Arrow*, a dirigible built by Baldwin, was piloted by Baldwin on the first successful controlled rigid dirigible flight in America. Baldwin joined with Glenn Curtiss to build and sell a dirigible (the army's first aircraft) in 1908 to the U.S. Army Signal Corps. In 1910, Baldwin designed a modified Curtiss pusher airplane, the *Red Devil*, which he flew in exhibitions around the world. (RC.)

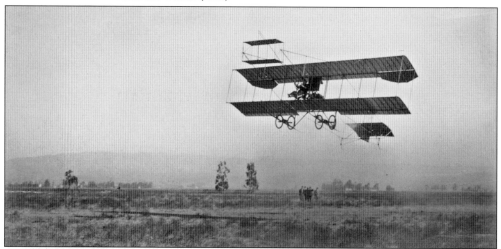

The No. 2 aircraft made by Fred Wiseman, backed financially by Ben Noonan, is very probably the aircraft that survives today in the Smithsonian Postal Museum next to the Union Terminal in Washington, D.C. On February 17, 1911, at 12:30 p.m., Fred Wiseman departed from the racetrack in Petaluma and headed for Santa Rosa carrying 50 copies of the *Santa Rosa Press Democrat*. He also carried a sack of coffee, which was to be delivered to a grocer. This is one of the first examples of the carriage of air cargo. His most important baggage consisted of three letters written in Petaluma that were to be delivered to Santa Rosa. After being forced down and remaining overnight, Wiseman completed the flight the next day. Thus Wiseman made the first airplane-carried mail flight officially sanctioned by a U.S. post office. (RC.)

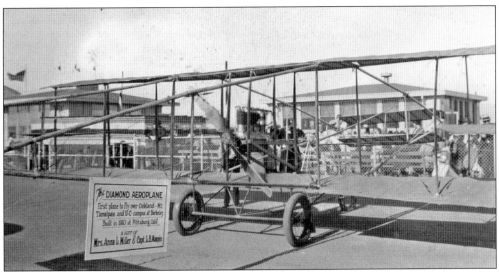

In Pittsburg, California, Land B. Maupin and Bernard P. Lanteri completed an aircraft in the spring of 1911 that was powered by an Elbridge engine. Lanteri flew the plane on its first trial. The airplane, which came to be known as the *Diamond*, was originally named *Black Diamond* after the coal mines in the Pittsburg area. Weldon B. Cooke became its pilot. He had practiced in Oakland beginning in July 1910 with a Montgomery glider and subsequently trained with the *Diamond* several times a day. Cooke made his first professional appearance in a series of flights at the Walnut Creek Grape Carnival, on October 6 and 7, 1911. His second public appearance was in Oakland, where he took part in the 1911 Columbus Day celebrations at Lake Merritt. The news accounts of this flight credit Cooke with "the unique distinction of being the first aviator to fly over Oakland," although apparently several others had flown in the Oakland area earlier. (RC.)

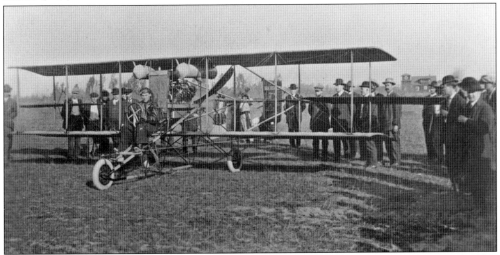

Silas Christofferson was a noted Bay Area pilot and aircraft builder along with several of his brothers. Silas is shown as the pilot of this Christofferson aircraft which, on February 9, 1914, he flew from San Francisco destined for San Diego, and landed near Bakersfield, completing the longest one-day, cross-country flight—271 miles—made in the United States to that date. On February 16, he finally negotiated the mountain passes and flew into Los Angeles, 382 miles from San Francisco. After a rest there, he flew on to San Diego. (RC.)

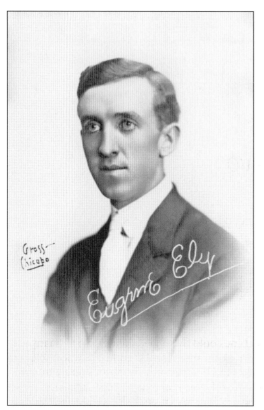

Eugene Ely was a highly regarded pilot, born in Iowa. He was an emergency-vehicle driver in the San Francisco earthquake of 1906 and was cited for bravery. He later attended the Curtiss School of Aviation and made the first landing of an airplane on a ship, the USS *Pennsylvania*, in San Francisco Bay on January 18, 1911. (WAM.)

The armored cruiser USS *Pennsylvania* was modified in the Mare Island Naval Shipyard for Ely's landing. A wood platform was built on the stern of the ship with horizontal cords attached to sand bags. Ely's Curtiss Pusher had a hook arrangement to catch one of the cords, and in case that didn't work, the rear gun turret was covered with padding. This photograph shows Ely after the landing and before he took off from the same platform to return to the Tanforan racetrack. (WAM.)

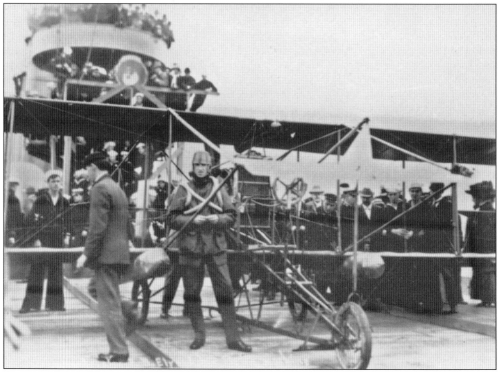

Two

THE ROARING
TWENTIES

In the 1920s, the idea that a heavier-than-air machine could fly seemed divine, and for many who for the first time watched a plane begin to move, pick up speed, and then lift its wheels clear of the ground, it was indeed "a miracle." Aviation prophets described the wondrous future in which planes would transform human existence. After World War I, daredevil pilots appeared across America. They were called "barnstormers" because their stunts included flying small planes through open barns. Schools would close and workers would leave businesses to watch these people perform. Americans were awed to see that humans could fly in machines and dive and bank like a swift falcon or an eagle.

The billionaire automobile manufacturer, Henry Ford in 1925, began producing eight-passenger aircraft. The next year, in 1926, Ford introduced the "Ford Flying Flivver." Although the prototype compared poorly with the Model T because it held but one person, it stimulated tremendous popular interest. In 1928, however, the diminutive plane crashed and killed its pilot, diminishing Ford's interest in aviation, even though he did manufacture the famous "Ford Tri-Motors" beginning in 1928.

The federal government kept the dream of wings for all alive during the Depression, mainly through the efforts of Eugene Vidal. A former World War I pilot and airline executive, Vidal became the head of the bureau of air commerce in the Roosevelt administration. In late 1933, he announced that the government would spend half a million dollars to produce a "poor man's airplane." He promised a two or three seat, all-metal machine costing $700, about the price of a Pontiac automobile and $300 to $500 less than any plane then on the market. Vidal's plan drew angry criticism. Manufacturers of small planes described it as an "all mental" airplane, an unrealistic fantasy that would only destroy the sales of existing aircraft. However, Vidal's proposal did result in a few prototype aircraft subsidized by his bureau.

In the 1920s and 1930s, schools, recreation programs, hospitals, department stores, radio stations, and newspapers actively supported model aeronautics. Publishing magnate William Randolph Hearst created the largest model-building organization, the Junior Birdmen of America. Hearst papers ran columns offering advice and tips to Junior Birdmen and sponsored flying meets where members competed for prizes. His faith in the winged gospel was embedded in the Junior Birdmen's motto: "Today pilots of models; Tomorrow model pilots."

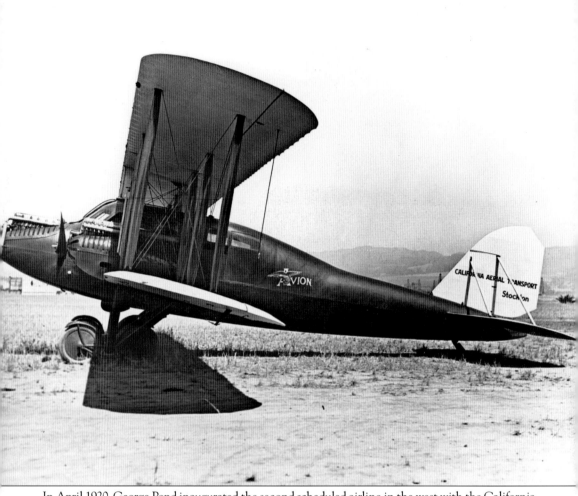

In April 1920, George Pond inaugurated the second scheduled airline in the west with the California Aerial Transport Company. With offices in Stockton, a route was laid out from Concord to Los Angeles via Stockton, Fresno, and Bakersfield. A new Curtiss Eagle trimotor named *Avion* was purchased, and the first flight started from Mahoney Field in Concord on June 7. Three flights a week were scheduled, but on June 26, the *Avion* crashed in Los Angeles, causing the company to disband in August. (LC.)

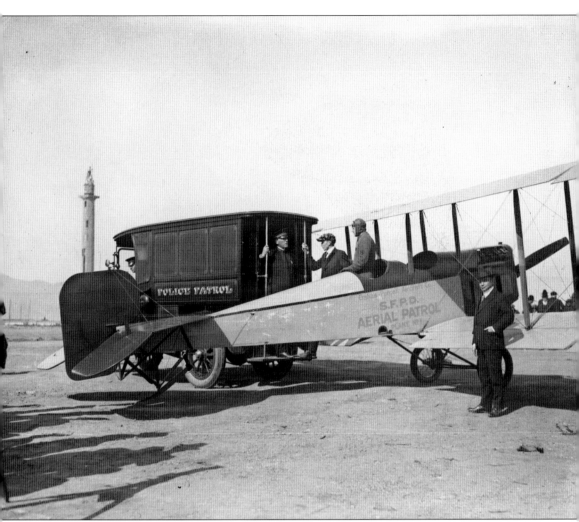

The San Francisco Police Department's "Paddy Wagon" is backed up to the Martin TT-1 owned by the Gates-Purcell Aircraft Company and operated for the SFPD as their "Aerial Patrol Plane No. 1." This publicity photograph, taken on the marina in 1915, is from a glass-plate negative in the Bowers Collection. (RC.)

The second plane designed and built by the Jacuzzi brothers of Berkeley in late 1920 was one of the first fully enclosed cabin planes. It was flown to various locations in Northern California but was lost in a fatal crash near Modesto, California, due to structural failure of the wing struts. One of the brothers was killed, and the other brothers then quit aviation and started a successful pump business. (LC.)

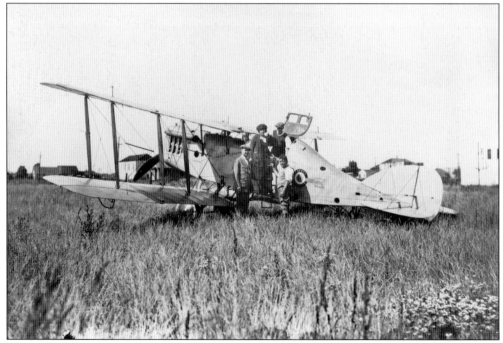

Peter Allinio started designing and building planes in El Cerrito in 1908, flying them from fields along Stockton Street and Fairmount Avenue. In 1923, he bought a surplus British Bristol fighter and modified it with a cabin to hold two people, as can be seen in this photograph. The plane flew for several years, including a trip to Los Angeles and back. (LC.)

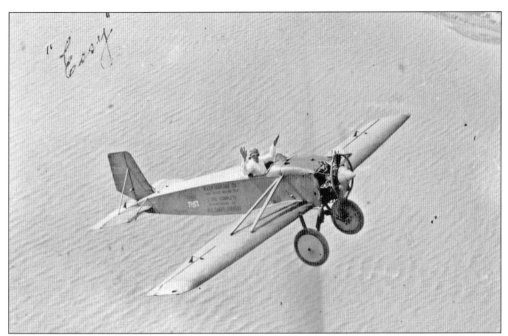

The WASP Airplane Company of Oakland produced a $1,200 single-place plane in the late 1920s. It was advertised as a safe and easy plane to fly, and "Sandy" Sanders, a local pilot and salesman for WASP, is shown here demonstrating hands-off flying over the Oakland-Alameda area. (RC.)

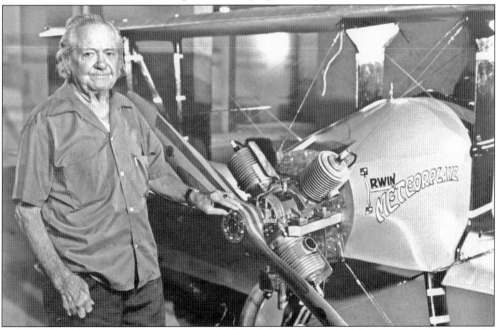

Jack Irwin was born in San Francisco and built and flew a "blimp" in the Sunset District in 1908. He is shown here in front of one of his self-designed 240-pound, 15-foot-long Meteorplanes, one of which is now on exhibit in the Oakland Museum. Irwin built and flew his first plane, a glider, in San Francisco as a boy and continued building airplanes into old age. He built over 1,000 airplanes in various locations in Northern California, many of them in kit form. (RC.)

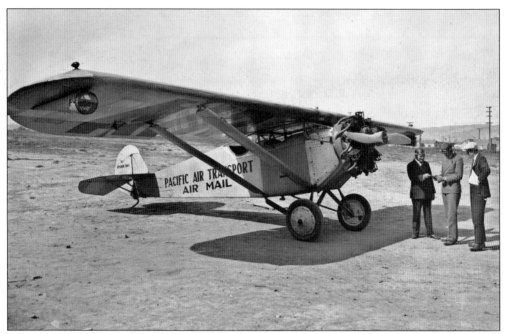

When Vern Gorst was awarded the airmail contract for Route 8 in 1926, he formed Pacific Air Transport and proceeded to establish airstrips at towns along the route. He ordered new Ryan M-1 passenger-mail planes for about $3,700 each and opened his main base at Crissy Field. By the end of August 1926, he had taken delivery of six new Ryan M-1s, as shown in this photograph. (RC.)

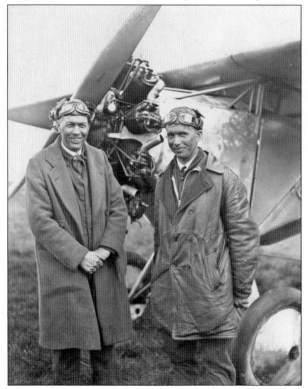

Vern Gorst, president of Pacific Air Transport, and T. Claude Ryan stand with one of PAT's Ryan M-1 mail planes in March 1926 after a survey flight for the San Francisco–Seattle route. (RC.)

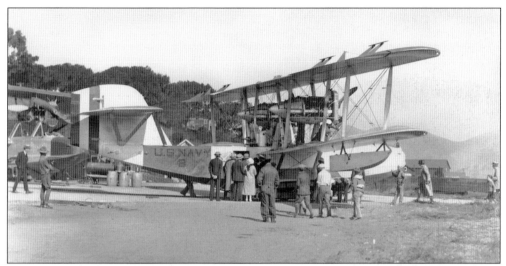

The navy PN-9 is shown at Crissy Field prior to its attempted flight across the Pacific Ocean to Hawaii in August 1925. The flight ended in the open sea after a record nonstop distance of 1,841 miles. They were 365 miles short of Honolulu, but the crew successfully "sailed" the aircraft to within several miles of Kauai by cutting the wing fabric to make a sail (RC.)

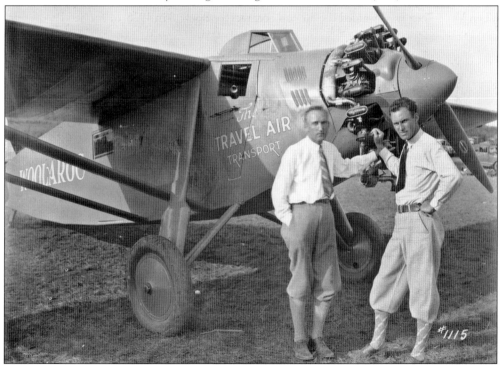

Walter Beech, left, and his modified Travel Air 5000, named *Woolaroc* for woods, lakes, and rocks, are pictured here with Arthur Goebel. On August 16, 1927, with Goebel as pilot and Lt. William V. Davis as navigator, it took off from Oakland as one of the last planes in the Dole Race. They landed in Oahu 26 hours and 17 minutes later to win the first prize of $25,000. The plane was sponsored by the Phillips Petroleum Company and is on display in Bartlesville, Oklahoma. (RC.)

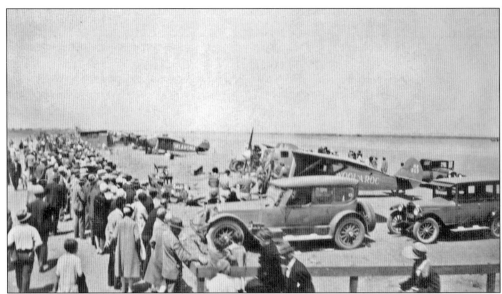

The North America–Honolulu Transpacific Flight—better known as "The Dole Race" because of its sponsorship by James Dole, the "Pineapple King," of Hawaii—brought together a mixture of civilian planes attracted by the $25,000 prize money for the first plane to arrive at Wheeler Field in Oahu, Hawaii. This photograph shows some of the preparation prior to departure on August 16, 1927. (RC.)

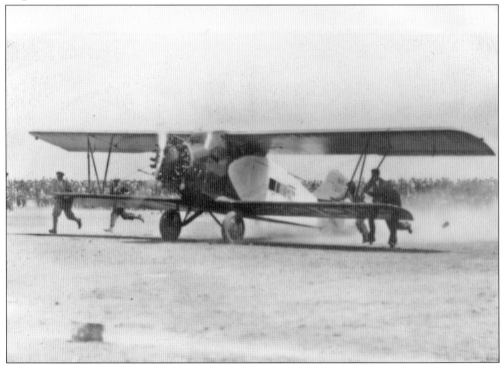

The *Miss Doran* took off on August 16 with John A. Pedlar as pilot, Lt. Vilas R. Knope USN as navigator, and Mildred Doran as a passenger. They were lost at sea after having been seen for the last time over the Farallone Islands. (RC.)

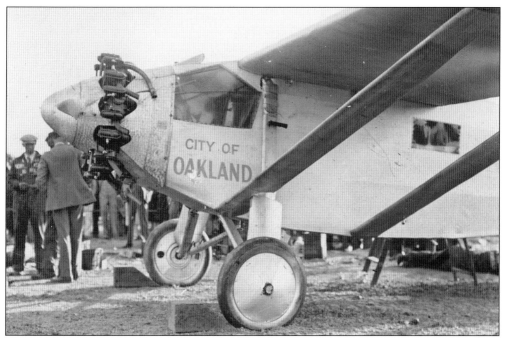

On July 14, 1927, just prior to the Dole Race, Ernie Smith and Emory Bronte took off in their Travel Air 5000, *City of Oakland*, from Oakland Airport and landed in a breadfruit tree on Molokai, Hawaii. It was the first civilian and first single-engine aircraft flight from North America to Hawaii. (RC.)

Ernest L. Smith attended Oakland High School and University of California, Berkeley and became a pilot in the U.S. Army in World War I. He flew for the U.S. Forest Service and Pacific Air Transport, as well as for the movie *Hell's Angels*. On July 14, 1927, with Emory Bronte as navigator, he flew this Travel Air 5000 to Molokai, Hawaii; they were the first civilians and the first single-engine aircraft to do so. (RC.)

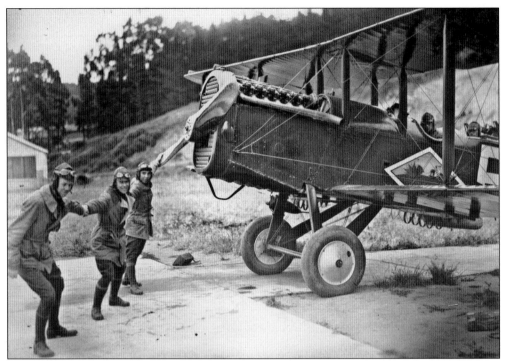

The three men "pulling the prop through" in this photograph demonstrate the standard method that was used for starting the engine of the DeHavilland DH-4. This World War I type was widely used by the services, including this one at Crissy Field about 1920. (RC.)

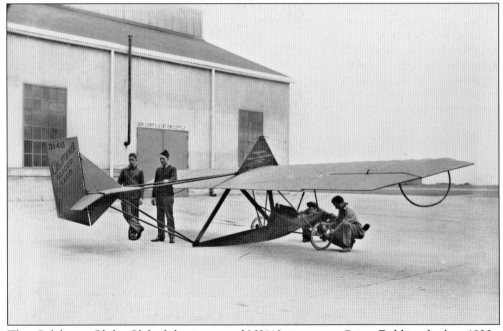

This California Glider Club glider, registered N3140, is seen at Crissy Field in the late 1920s. Early glider flying in the Bay Area included the Martinez Glider Club. Member Emmett Horgan flew a glider from the top of Mount Diablo in January 1934. (RC.)

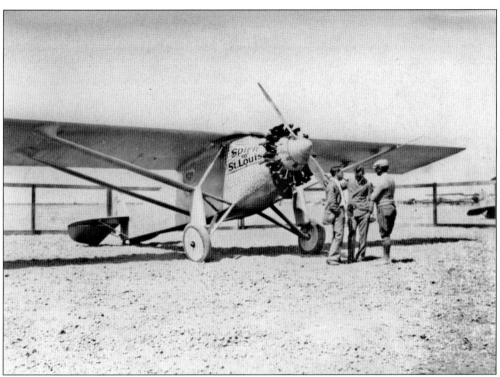

This is one of the few photographs known of the *Spirit of St. Louis* at Oakland on September 17, 1927, when Charles Lindbergh landed to dedicate Oakland Airport. He was on a flying tour of 48 states to commemorate his solo flight from New York to Paris across the Atlantic. (RC.)

Guy Turner, first manager of Oakland Airport, walks with Charles Lindbergh on September 17, 1927, as he was about to dedicate the airport. (RC.)

In 1926, Howard Hughes went to Hollywood and began making movies. He made a movie called *Hell's Angels* about World War I flying, but it was silent, which was the standard at the time. The movie was just about to be released when sound films were invented, so Hughes remade the nonflying scenes, creating a major epic in motion-picture history when it premiered in March 1930. Hughes brought 100 men and 40 planes to Oakland, where much of the flying was done, in 1928. This publicity photograph shows an authentic S.E.5 and Fokker D-VII in formation. Several of the planes had 35mm cameras mounted on the rear fuselage. (LC.)

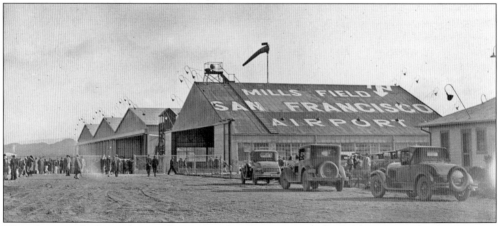

This photograph shows the new hangars at San Francisco's Mills Field in 1928. The first hangar, with the airway marking on the roof, was completed in late 1927. The 24-inch rotating beacon, above the letters SAN, was an important addition for night flying. The small structure on the right was the first airport administration building. It was a dirt field, as can be seen, like all airports of the time. (LC.)

From left to right, general superintendent of the U.S. Post Office Airmail Service, Carl F. Egge; O. C. Richerson, western region superintendent; and Porter D. Bush stand in front of a DeHavilland DH-4 mail plane at the airmail field on West Street in Concord in 1926. Two thousand people came to the dedication of the Diablo Air Mail Field on February 3, 1925. (LC.)

This photograph of the Boeing 40A *San Francisco* with the pilots, mechanics, and staff is one of the last taken before Diablo Field was closed on December 15, 1927. The mail and passenger service was moved to the new Oakland Airport, and the field remained dormant until it was reopened as Concord Airport on March 23, 1941. San Francisco Bay Airdrome had to be closed because of its proximity to the new NAS Alameda, so several pilots moved to Concord with their planes. But the start of World War II closed the airport on December 8 for the last time. (LC.)

The U.S. Army Fokker (Atlantic C-2) *Bird of Paradise* is shown at Crissy Field before it was flown across the bay to Oakland Airport for the departure on June 28, 1927, for its historic flight to Hawaii. The pilot was Lt. Lester Maitland, and the copilot/navigator was 1st Lt. Albert Hegenberger, both of whom have streets named after them today at Oakland International Airport. The plane loaded with fuel was too heavy to take off from Crissy, so the safer and longer runway at Oakland was used for the flight of 2,407 miles, which took 25 hours and 50 minutes. (LC.)

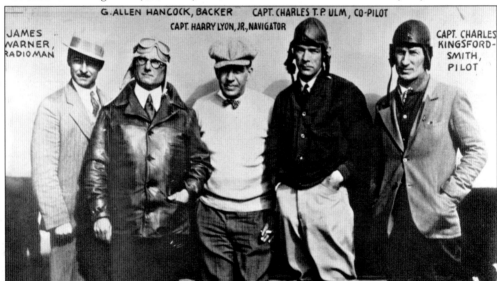

Capt. Allan Hancock of Santa Maria purchased the Fokker trimotor *Southern Cross* and leased it to Charles Kingsford Smith and Charles Ulm to make a record flight possible. He is shown here with the full crew that took off from Oakland on May 31, 1928, to make the first transpacific flight to Brisbane, Australia. They flew 7,800 miles in 88 and one half hours flying time, arriving on June 10. Kingsford Smith and Ulm were Australian, and Lyons and Warner were American. (RC.)

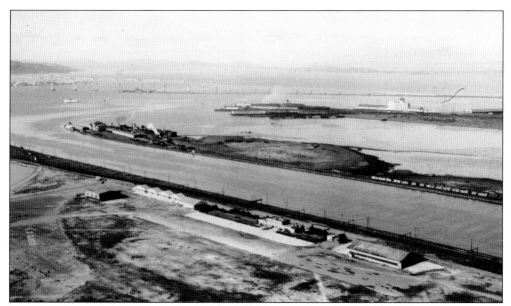

This aerial view of Alameda Airport shows it alongside the electric railway going to the ferry boats at the Oakland Estuary. It had a 2,500-foot, east-west runway and a 24-inch rotating beacon. The increase in beacons was a great improvement for the airlines starting to fly at night. The largest one in the United States was a 10 million-candlepower rotating beacon on a 75-foot steel tower on the top of Mount Diablo. It was turned on by Charles Lindbergh on April 15, 1928, and could be seen for 100 miles. (WL.)

Alameda Airport was a busy place when it was first built with service by Maddux Air Lines Ford Tri-Motors and several hangars full of private aircraft. Aviation was still an exciting new adventure, and it drew crowds to come and see airplanes coming and going as seen in this photograph of the terminal building in 1929. (LC.)

This Huff-Daland Petrel 5 is running up its Hispano-Suiza engine at Alameda Airport in 1928. It was owned by William A. Geary of Alameda and registered N5171. (LC.)

A Standard J-1, with children in front of it, owned and flown by Dr. Lehi Torrey, is pictured at Bay Farm Island Airport in Alameda in 1920. Bay Farm Island Airport was located on the Alameda side of the boundary with Oakland on Bay Farm Island adjacent to the levy along the bay. The airport was also called Alameda Airport and opened about 1920. It closed in 1928 when the new Oakland Airport opened in very close proximity. Some pilots and authors incorrectly called the Oakland Airport Bay Farm Airport. Lehi Torrey, Ben Torrey, and "Sandy" Sanders all had much to do with the Bay Farm Airport. (RC.)

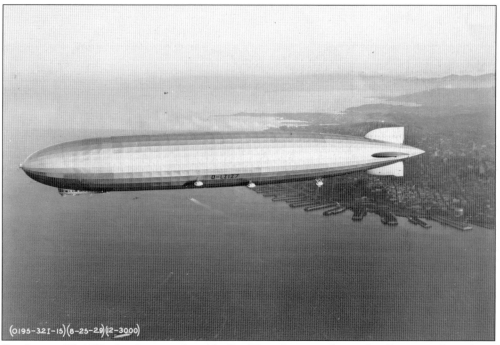

On August 25, 1929, the German dirigible *Graf Zeppelin* arrived over San Francisco Bay after a 67-hour, nonstop flight from Tokyo, Japan. The round-the-world flight was backed by $100,000 from William Randolph Hearst. The airship did not stop in the Bay Area but continued on to Los Angeles before landing. However, it was a sensational event that brought thousands of people out to watch as the craft toured the Bay while escorted by navy and army reserve planes from Oakland. (RC.)

The Russian ANT-4 *Land of the Soviets* landed in Oakland on October 19, 1929, during a goodwill flight from Moscow to New York City. After arriving from Seattle, the four-man crew flew to Salt Lake City. The total flight took 142 flying hours and covered 13,300 miles. (LC.)

On January 21, 1928, the Thaden T-1 Argonaut was built by the Thaden Metal Airplane Company with Herbert Von Thaden as president. Parts were made in San Francisco and then assembled in D. C. Warren's hangar at Oakland Airport. This photograph shows the smaller four-place T-2, which was not continued in production because of the Great Depression. The fuselage of a T-2 recovered from Alaska is now on exhibit in the Hiller Aviation Museum. (RC.)

The *Golden Bear* was manufactured by the Neilson Steel Aircraft Corporation of Berkeley and is seen here at the Berkeley Airport on June 13, 1929. It was destroyed 10 years later as part of a "thrill show" at the Oakland Speedway. Instead of crashing into a "house," it landed short, and the disappointed crowd poured onto the field and tore the plane apart. (LC.)

Three

THE GOLDEN YEARS

When Orville and Wilbur Wright flew history's first airplane for 120 short feet in North Carolina in 1903, the significance of their new invention was of course not yet apparent. But in 1927, Lindbergh's transatlantic flight captured America's imagination. Lindbergh, a barnstormer, flew a small airplane, the *Spirit of St. Louis*, for 33 hours from New York to Paris. When his safe arrival in Paris was announced, league ball games stopped, and radio announcers sobbed. Humans, who had always looked to the sky and stars with wonder, could now cross vast oceans with amazing speed by taking to the sky.

Henry Ford's "Ford Tri-Motor," introduced in 1928, accommodated 13 passengers in its earliest model and was modified to seat up to 17. With no air conditioning and little heating, the plane was hot in summer and cold in winter, and with no circulation system, its environment was made even more unpleasant by the smell of hot oil and metal, leather seats, and the disinfectant used to clean up after airsick passengers. Opening a window was the only way to escape the smell. The Boeing 80 was somewhat more comfortable, equipped with forced-air ventilation and hot and cold running water. The Ford Tri-Motor could reach about 6,000 feet, but its climb to that altitude was slow, and the plane would surge upward, level off, bump around, and drop repeatedly before it reached its cruising altitude. The Boeing Model 80 had a higher ceiling, 14,000 feet, but was still subject to turbulence.

With the introduction of the Douglas DC-2 in 1934 and the DC-3 in 1936, air travel became much more comfortable and somewhat more commonplace. The DC-2 could fly coast-to-coast faster than any passenger plane before, and the DC-3 had both day and sleeper models, allowing passengers to travel cross-country in comfort. While the earlier trimotors had been plagued by engines that transmitted noise and vibration back to the passengers, Douglas planes added soundproofing to cabins and ventilation ducts. Upholstered seats mounted on rubber and padded arm rests further reduced noise and vibration. The DC-3 cut the cost of flying in half and made airlines a profitable business. But at a cost of 5¢ per mile to transport one passenger, air travel was still expensive for the average person. Train travel cost only 1.3¢ per passenger mile and was more comfortable. But a whole class of people, such as businessmen who put a money value on their time, could afford to fly on company expense accounts. They did, in soaring numbers.

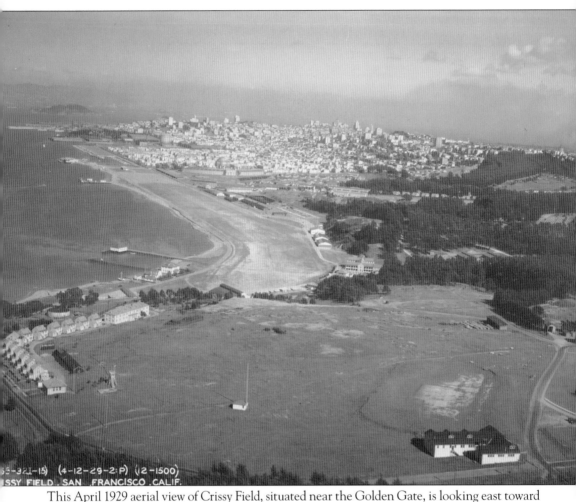

This April 1929 aerial view of Crissy Field, situated near the Golden Gate, is looking east toward the city of San Francisco. Takeoffs were made to the west in a climbing right turn to avoid the hills in the foreground. (LC.)

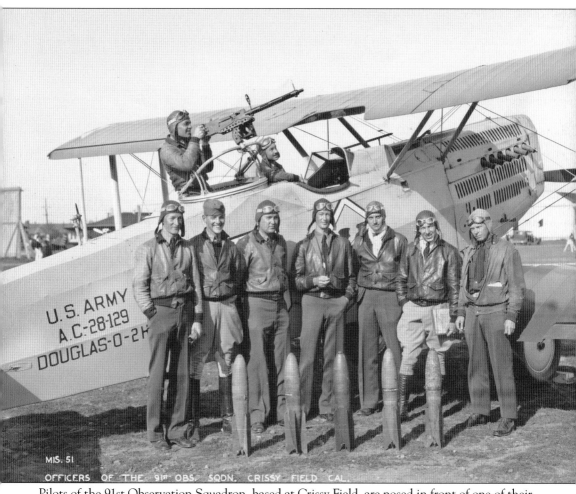

Pilots of the 91st Observation Squadron, based at Crissy Field, are posed in front of one of their Douglas O-2H observation planes. The observer in the rear cockpit is demonstrating the seldom-used machine gun. (LC.)

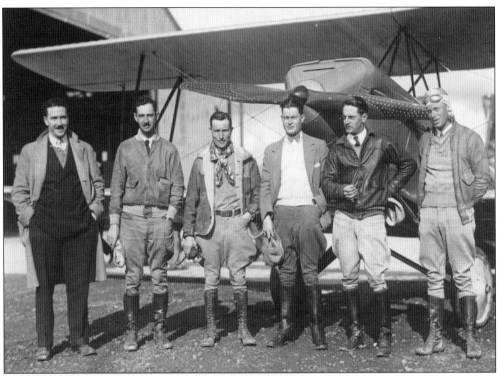

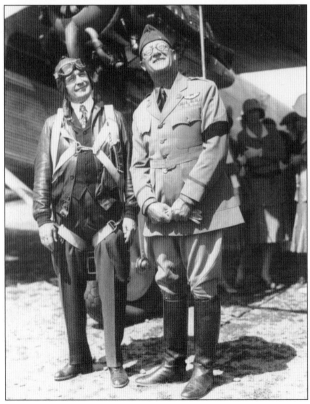

This photograph was taken in the 1920s. From left to right, they are unidentified, possibly Emory Bronte of the "Dole Race", unidentified, Franklyn Rose, Sandy Sanders, and Denny Wright with Travel Air in background. Note the "britches" and long flying boots worn by five of the six men, common flying costumes of that time. (RC.)

Gen. William Gilmore, shown in uniform with a civilian in a parachute harness, is standing in front of a Ford Tri-Motor. Gilmore was an active-duty general who visited the Bay Area periodically to stage major Army Air Corps events and air shows. He retired in the area and was an active member of the local Quiet Birdmen chapter. (RC.)

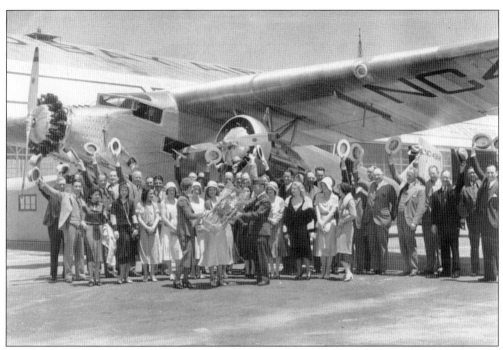

City officials and others are celebrating the inauguration of Pacific Air Transport's service from Seattle to San Diego as it passes through the San Francisco Bay Airdrome in Alameda on May 28, 1931. The new Ford 5-AT-D provided a daily two-way passenger schedule. (LC.)

Boeing Air Transport provided service east from the Bay Area. This Boeing 80-A is parked at the loading gate of the new passenger area in Hangar No. 5 at Oakland Airport. On May 29, 1929, the first transcontinental night airmail, passenger, and express service was inaugurated from Oakland to Chicago with Ray Little as pilot. (RC.)

Vern Gorst initiated San Francisco Air Ferries Limited in February 1930 using Keystone-Loening seven-seat amphibian Air Yachts. Gorst charged $1.50 to cross the bay from Pier No. 5 in San Francisco to the foot of Franklin Street in Oakland. In the first six months of operation, Air Ferries carried 46,000 people, averaging 254 a day. At its peak operation, the fleet of four planes crossed the bay every 20 minutes. In 1930, the astounding record was 30 trips a day each way and 60,000 passengers carried. (RC.)

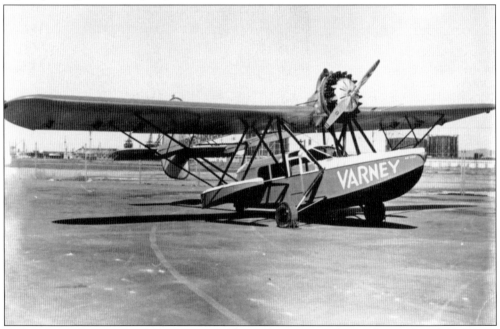

Walter Varney, born in San Francisco, created five airlines. In March 1932, he purchased Air Ferries from Vern Gorst. In July, the service was moved from the foot of Franklin Street in Oakland to the San Francisco Bay Airdrome in Alameda. He operated hourly flights to San Francisco with newer Sikorsky S-39s, as shown here. The service ended in 1934. (RC.)

Franklin Rose (standing), chief pilot, and Pop Wilde, chief of maintenance for Varney Speed Lines (later Varney Speed Lanes), are pictured with one of the their fast Lockheed Orion passenger planes at San Francisco Bay Airdrome in 1931. By 1933, Varney was flying four times a day to Los Angeles and six times a day to Sacramento. Advertised as "The Fastest Airline in the World," it flew from Alameda to Glendale in one hour and 58 minutes for a fare of $18.95 one way. (LC.)

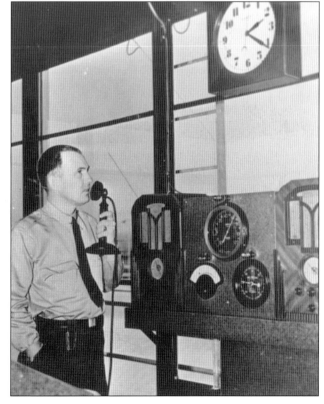

Fred McElwain, longtime (1927–1965) Oakland Airport superintendent, is shown here in the early "tower" at the airport. McElwain, a former U.S. Navy pilot, was very innovative and helped develop air-traffic control, communications, and navigation systems. (RC.)

The British made Airspeed Envoy *Stella Australis* at Oakland prior to its departure on November 30, 1934, for Hawaii in an attempt to fly to Australia. The crew consisted of Capt. Charles Ulm, copilot George Littlejohn, and radio operator-navigator Leon Skilling. The aircraft disappeared near Hawaii and was never found. Ulm had been copilot with Charles Kingsford-Smith on the first transpacific flight from Oakland to Australia in 1928. (RC.)

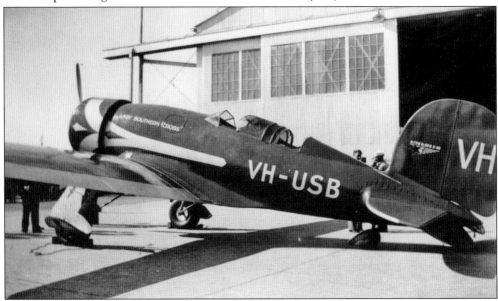

Flown by Charles Kingsford-Smith and Capt. P. G. Taylor, the Lockheed Altair *Lady Southern Cross* landed in Oakland on November 4, 1934, after a successful flight across the Pacific from Brisbane, Australia, via Fiji and Hawaii. (RC.)

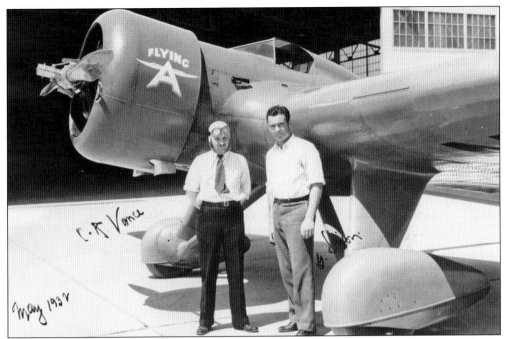

Claire Vance and George Dixon are pictured in front of the Vance twin-boom *Flying Wing* at Oakland Airport in 1932. The plane was designed to fly cargo, but after Vance was killed flying the mail in December 1932, it remained unused until an attempt was made to enter it in a cross-country race. (LC.)

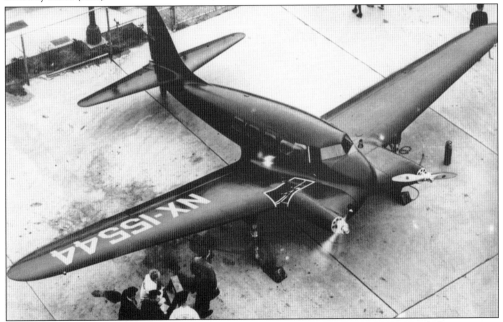

Alan Lockheed built the molded-plywood Alcor C6S1 at Oakland Airport. It was a light transport with two Menasco in-line engines. It had flown to Los Angeles and back but was lost on a test flight over the bay off Bay Farm Island on June 27, 1938. Casserly and Webb both parachuted safely from the plane after a dive caused wing-tip destruction. (RC.)

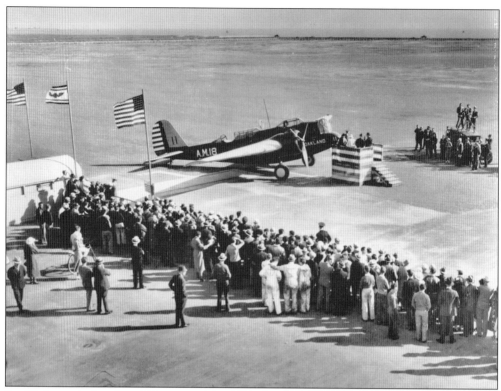

For 80 dramatic days from February to May 1934, the Army Air Corps was ordered by President Roosevelt to carry the U.S. mail. Maj. Clarence Tinker was put in command of the Oakland–Salt Lake City–Cheyenne route and started operations with Douglas B-7 bombers. These were replaced in April by new Martin B-10 bombers, and this photograph shows the christening ceremony for one named the *City of Oakland*. The last flight from Oakland was on May 7. (RC.)

Lt. John S. Chennault, son of Lt. Gen. Claire Chennault of Flying Tiger fame, is seated in his Boeing P-26A of the 94th Pursuit Squadron on a visit to Oakland from Selfridge Field, Michigan, in May 1936. (WL.)

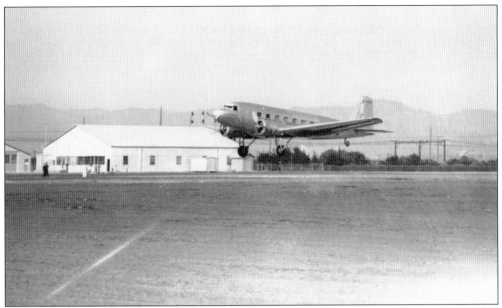

A Pan American Airways Douglas DC-2 lands at Alameda on August 19, 1935, bringing the bodies of Wiley Post and Will Rogers from Seattle after their fatal crash in Alaska. After refueling, the plane went on to Los Angeles. Jim Fleming was copilot on this flight. (LC.)

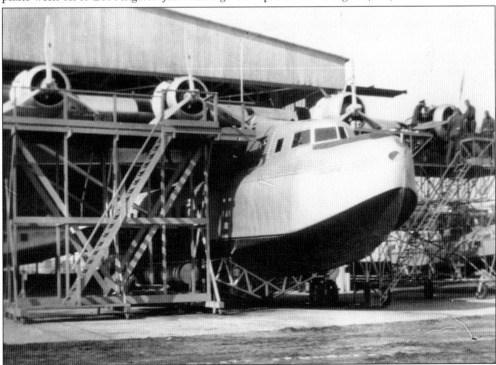

This photograph shows engine maintenance being performed on the Pan American Airways Martin 130 *Philippine Clipper* at Alameda in 1936. Another Martin 130 is in the hangar, and the Consolidated Commodore training plane is on the right. This is a sample of history preserved by a 14-year-old enthusiast with a box camera. (WL.)

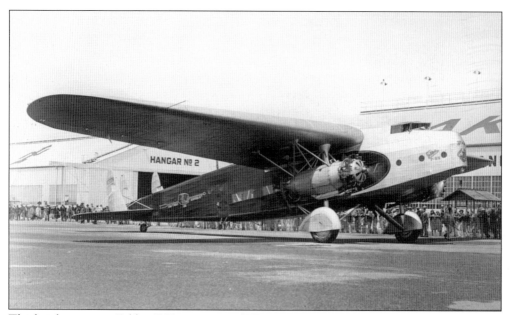

The big four-engine Fokker F-32 transport of Western Air Express attracted a lot of people to Oakland Airport in 1930. The flying time to Alhambra was three hours, and the fare one way was $21.50, but the operation with this plane proved to be too expensive to continue so it was a rare occurrence while it lasted. (OC.)

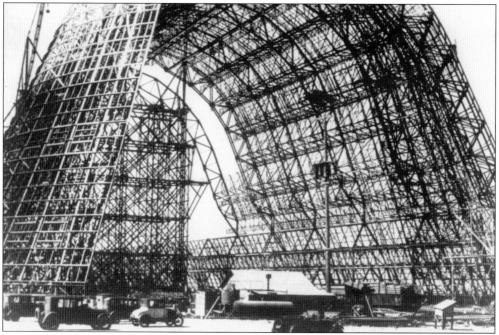

Construction of Hangar No. 1 at Moffett Field (originally Naval Air Station Sunnyvale) took place between 1931 and 1933. This photograph shows the metal framework going up in 1932 on one of the largest dirigible hangars in the world, being 1,133 feet long, 308 feet wide, and 198 feet high. Built to house the USS *Macon* on the West Coast since the USS *Akron* was on the East Coast, its fate in 2006 is still undetermined. (RC.)

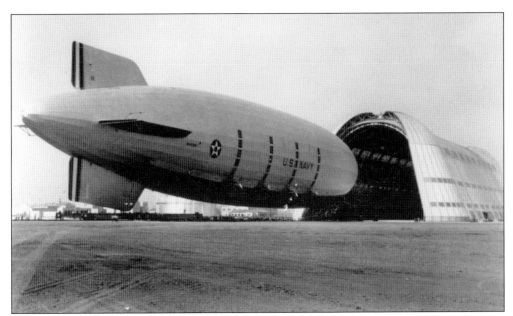

Eight engines powered the USS *Macon* on its coast-to-coast flight of 70 hours, arriving on October 15, 1933. The dirigible was 785 feet long and 146 feet high, so it was moved into the hangar on rails to be "docked," as is said in proper navy terminology. It flew from Moffett Field until February 12, 1935, when it was lost in a storm near Point Sur below Monterey, California. (RC.)

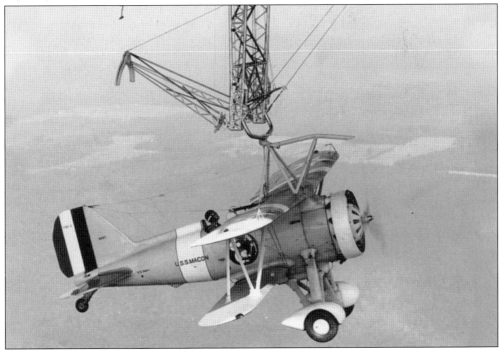

The USS *Macon* is often remembered for its Curtiss F9C-2 Scout planes. Four of these small fighters were modified for the special arrangements built into the airship that allowed the planes to be launched and retrieved from a retractable mechanism. This photograph shows the initial hook-on before the stabilizing arm dropped to the rear fuselage. (LC.)

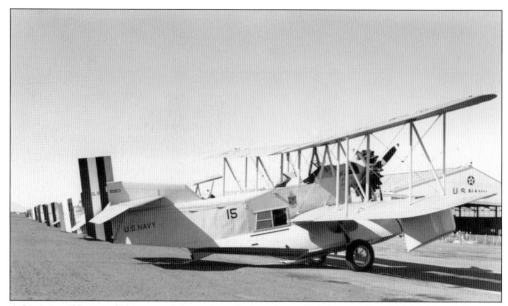

A Loening OL-9 and the rest of the assigned aircraft are lined up in front of the Naval Reserve Aviation Base Oakland's Hangar No. 3 in 1938. Each NRAB near water was assigned an amphibian for possible rescue work. (WL.)

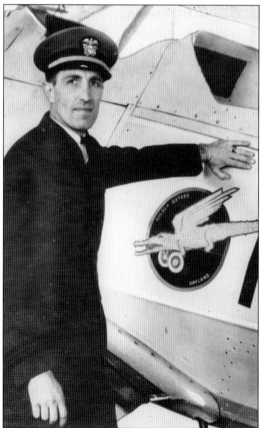

Lt. Cmdr. Francis B. Connell, USNR, first commander of the Naval Reserve Aviation Base at Oakland, is pictured here in 1928. He is standing next to the station insignia on a Curtiss O2C-1. "Golden Gators" was the theme used during the 1930s, showing its proximity to the Golden Gate. (RC.)

Amelia Earhart's Lockheed 10-E is shown here at Oakland Airport on March 14, 1937, just before her flight to Hawaii on her first attempt, westbound, to fly around the world at the equator. The plane ground-looped on takeoff in Hawaii, and after repairs, it departed Oakland a second time on May 20, 1937, headed east for a second attempt. Earhart and her navigator, Fred Noonan, were lost when the plane disappeared in the mid-Pacific near Howland Island. (WL.)

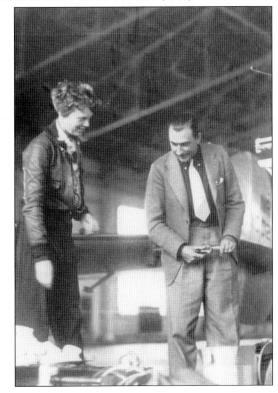

Amelia Earhart and Paul Mantz are shown here in the naval reserve hangar at Oakland Airport weighing items to be carried on the flight to Hawaii. Earhart made a transcontinental flight to Oakland in an autogiro in June 1931 and flew from Hawaii to Oakland in her Lockheed Vega in January 1935 for a first solo transpacific flight record. (WAM.)

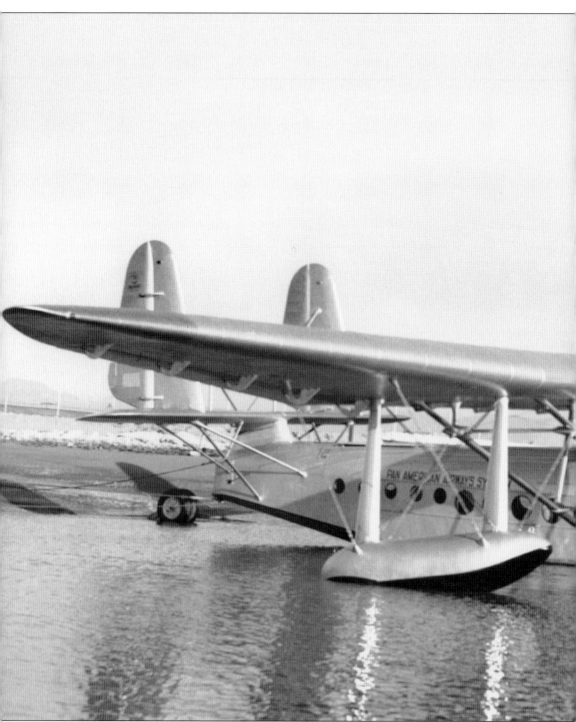

The Sikorsky S-42 was used by Pan American Airways to develop the routes to the Pacific. In March 1937, Capt. Edwin Musick and crew left Alameda to make the first survey flight to New Zealand. On December 23, 1937, a second flight using the "Samoan Clipper" began service between San Francisco and Auckland carrying only mail and small packages. On the third trip

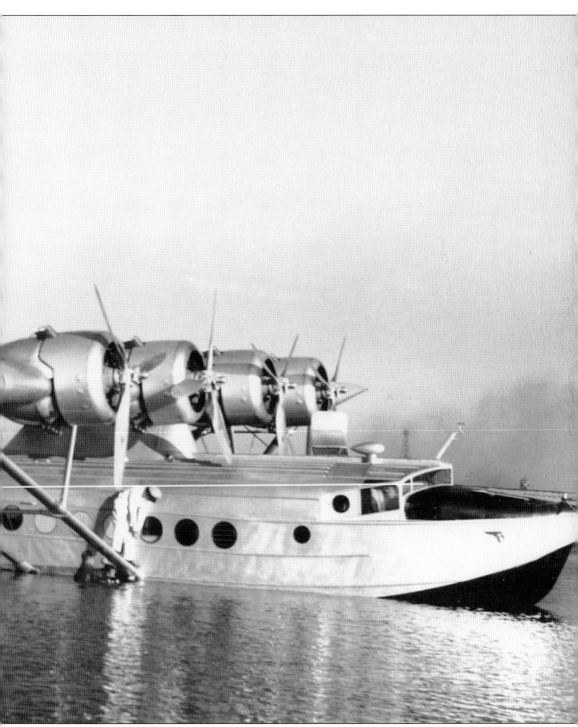

this Sikorsky S-42B NC-16734, shown at Alameda in the summer of 1937, crashed at Pago Pago, Samoa, on January 11, 1938. Captain Musick and his crew were lost with the aircraft when it exploded while dumping fuel during a precautionary landing. (WL.)

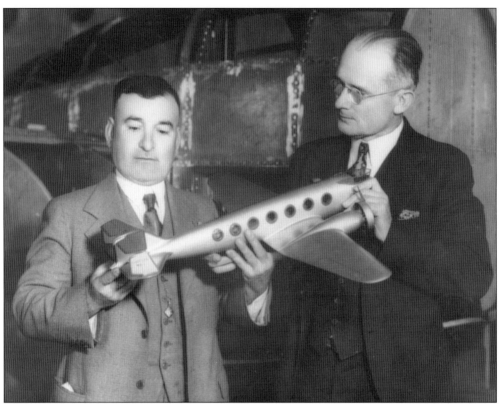

Socrates Capelis and Prof. John Younger hold a model, built by Gordon Lamb, of the proposed Capelis C-12 all-metal passenger plane to be built by the Capelis Safety Airplane Corporation of Oakland in 1933. (LC.)

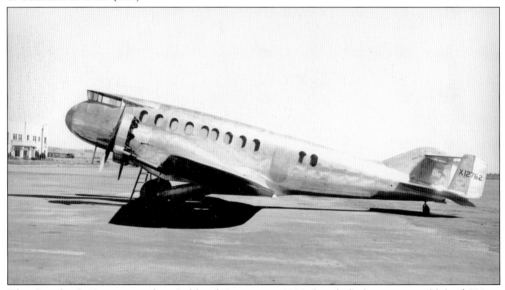

The Capelis C-12 is pictured at Oakland Airport in 1938 shortly before it was sold for $500 to the RKO movie studio. Its longest flight was its delivery to Los Angeles, where it was used in a nonflying sequence in the movie *Five Came Back*. (WL.)

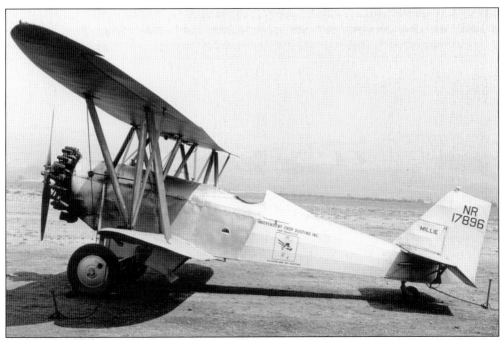

This modified New Standard D-27 was operated by the Independent Crop Dusting Company of San Francisco and has an insignia and the words "Oil Vapor and Dry Dusting" on the side. The photograph of *Millie* was taken at the San Jose Airport in 1939. (WL.)

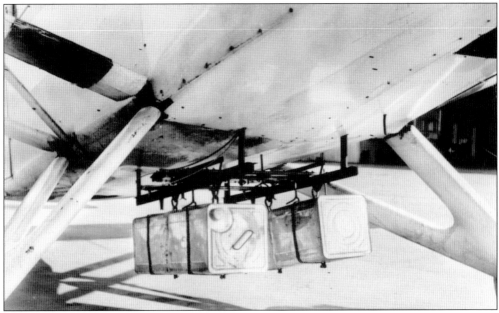

One of the earliest experiments in aerial firefighting was carried out at Livermore in February 1937. A Travel Air S-6000-B from the Duck Air Service at Oakland Airport was fitted with external racks and two 10-gallon cans filled with a chemical mixture designed by the physics department of the University of California, Berkeley. Sixteen flights were made for the U.S. Forest Service at Livermore resulting in the conclusion that this operation was ineffective. (LC.)

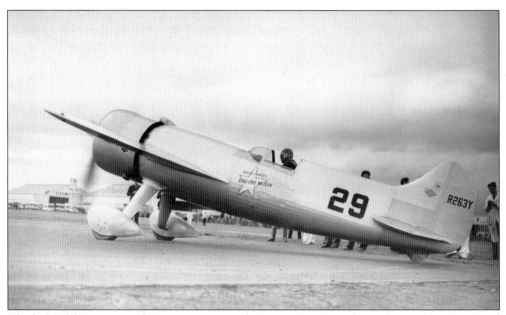

The beautiful Turner-Laird "Meteor" racer, with Roscoe Turner in the cockpit, is being prepared for a test flight at Oakland Airport prior to the 1938 Air Races. Turner lost to Earl Ortman in the final Golden Gate International Exposition Trophy Race by only 82/100ths of a second at 265.457 miles per hour. Both pilots exceeded the world closed-course speed record. (WL.)

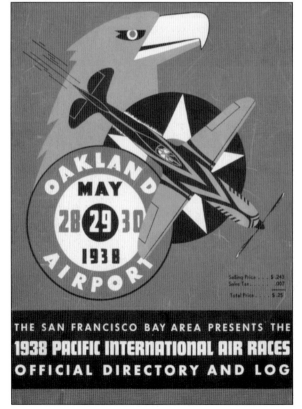

This attractive, 9-by-12-inch, 36-page race program with a red cover, photographs, and information sold for only 25¢. (LC.)

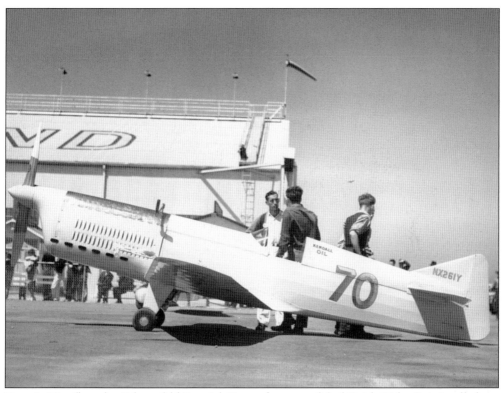

Tony LeVier flew the Schoenfeld Special *Firecracker*, a modified Keith Rider R-4, in all three races at Oakland. He came in third behind Roscoe Turner in the main event on May 30, 1938, with a speed of 260.762 miles per hour. (WL.)

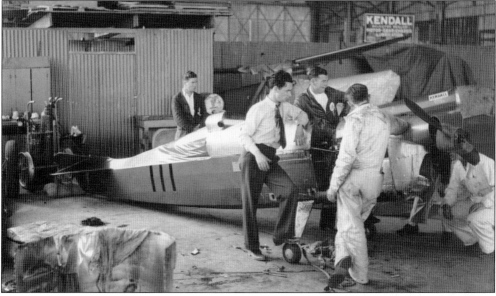

The drama and heartbreak of air racing are seen in this photograph of Steve Wittman's *Chief Oshkosh* racer being examined by his crew inside a hangar at Oakland Airport after his forced landing on May 30 during the sixth lap of the GGIE Trophy Race. (WL.)

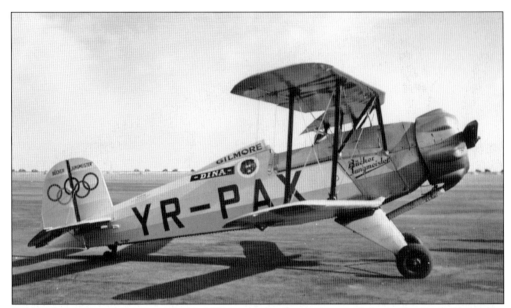

One of the most popular events at the 1938 races was the acrobatic exhibition by Capt. Alexandro de Papana of Roumania. His German-built Bucker Jungmeister was considered to be the best acrobatic plane in the world at the time. Tex Rankin had a hard time competing as his Ryan STA was not designed for acrobatics. (WL.)

This Taylor J-2 of Moreau Flying Service had a minor accident at Oakland Airport in 1938. It is being slowly towed on one wheel by the airport service truck while friends in a Ford Model A convertible hold up the wing. (WL.)

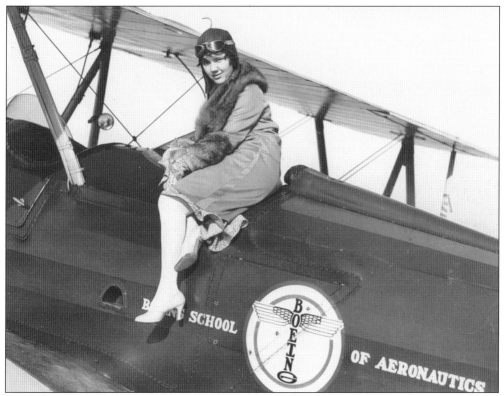

Jean Steffan was the first of two female students at the Boeing School of Aeronautics at Oakland Airport to take the course leading to a private pilot's license. This posed publicity photograph shows her with one of the school's Boeing 203-A trainers. (RC.)

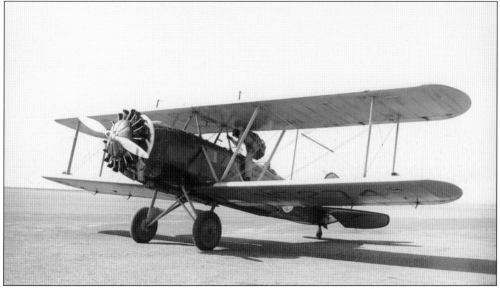

The Boeing School program leading to an air-transport pilot's license used this Boeing 40B, NC-274, a former mail and passenger plane on the Boeing air-transport route from Oakland to Chicago route. It was still in use when this photograph was taken in 1939. (WL.)

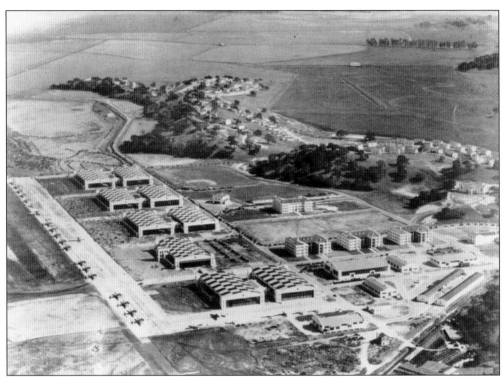

Martin B-10 bombers are shown lined up on the ramp of Hamilton Air Base about 1935. The photograph shows the Spanish-style housing area on the ridge between the airfield and Redwood Highway (U.S. 101). Hamilton was a choice assignment for many career air-corps officers, as the base facilities—as well as the area—were very attractive. A lot of the open land was filled in during World War II and later. This once very active base was made into an air-force reserve base and an active-duty, coast-guard airbase after the Korean War, and after the Vietnam War, it was made into an army-reserve airfield, operating primarily helicopters before it was closed in the early 1990s. (RC.)

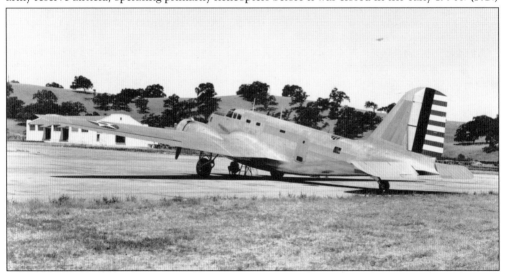

Pictured here is one of the Douglas B-18 bombers assigned to Hamilton Field. This July 1937 shows the rolling hills, grass, and trees surrounding Hamilton Field. (LC.)

Four

EXPANSION AND DEVELOPMENT

The decaying military situation in Europe in the late 1930s emphasized the need for action within the United States. In 1938, President Roosevelt dramatically called upon the U.S. aircraft industry to produce 10,000 planes per year. In the summer of 1940, Roosevelt upped his appeal to 50,000 planes per year, a tremendous increase compared with the 1,800 produced in 1938. According to an act passed in June 1939, the pilot-training program for the Air Corps was accelerated, with civilian contractors being selected to operate a large number of newly established primary flying schools where student pilots could begin their primary training in the Civilian Pilot Training Program. A huge buildup of men and equipment was under way.

Meanwhile the U.S. Navy went through similar expansion. On January 7, 1942, President Roosevelt approved expansion of naval aviation to 27,500 useful planes. On February 1, 1942, the U.S. Navy announced that all prospective naval aviators would begin their training with a three-month course emphasizing physical training, and it would be conducted by preflight schools to be established at universities in different parts of the country. St. Mary's Pre-Flight in Moraga was one of them.

After the attack on Pearl Harbor on December 7, 1941, on December 26, the U.S. military issued a ruling prohibiting private flights within 150 miles inland of the West Coast and ended operations for the time being at many small airfields. Both San Francisco and Oakland Airports went under U.S. Army command as did many other Northern California airfields.

In February 1939, Pan American Airways moved its West Coast operations from Alameda to a new seaplane base at the Golden Gate International Exposition on Treasure Island, a man-made island in the middle of San Francisco Bay. Treasure Island was built as the site for the fair and as a municipal airport for the San Francisco Bay Area. As part of the Pan Am exhibit, seen by more than 2.5 million visitors, plate-glass windows were installed in one of Treasure Island's hangars and one of the flying boats was kept on display at all times.

After the Pearl Harbor attack, plans for a civilian airport at Treasure Island were shelved. By 1944, the U.S. Navy's facilities on the island had become so large and ship traffic in the bay had become so heavy that Pan American moved to San Francisco Airport. Flying-boat service at Treasure Island was suspended shortly after the end of the war. Land-based planes had rendered the "Clippers" obsolete. Following the war, the U.S. Navy traded land at Mills Field for Treasure Island. Treasure Island was selected for closure by the 1993 Base Realignment and Closure Commission.

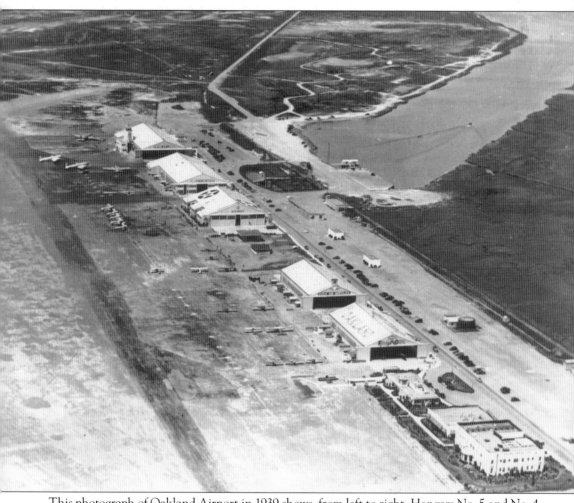

This photograph of Oakland Airport in 1939 shows, from left to right, Hangars No. 5 and No. 4, United Air Lines and some of their DC-3As, Hangar No. 3 naval reserve, exhibit building, coffee shop, Hangars No. 2 and No. 1, administration building, restaurant, and airport hotel. The hotel, opened as the Airport Inn on July 15, 1929, was the first airport hotel in the United States. The seaplane ramp and a visiting floatplane can be seen across from Hangar No. 4. (OC.)

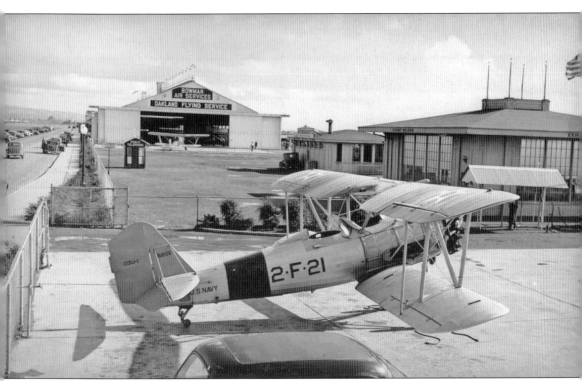

This is a photograph of the airport in 1937 in San Diego taken from the ladder on the side of Hangar No. 3. A visiting Vought O3U-1 from VF-2 is in the foreground, next on the right is the exhibit building that housed the 1911 Wiseman-Cooke and Black Diamond airplanes, next to that is the coffee shop, and past the open area is Hangar No. 2 with Bowman Air Services and Oakland Flying Service. (WL.)

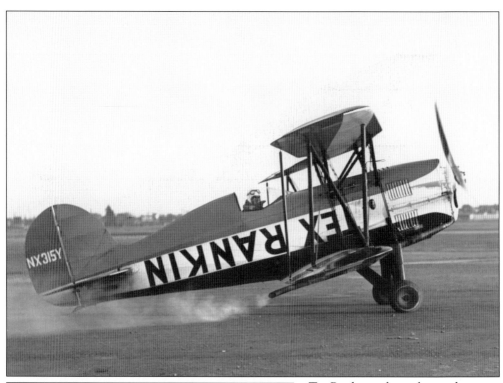

Tex Rankin is shown here in his modified Great Lakes 2T-1A about to take off as part of his "Tex Rankin's Hollywood Aces" air show at San Francisco Bay Airdrome in 1939. Rankin specialized in upside-down flying and arrived that way on many occasions at Treasure Island during the 1939 Golden Gate International Exposition. (WL.)

John G. "Tex" Rankin was the best-known acrobatic pilot in the United States in the 1930s. After learning to fly in the U.S. Army Air Service in 1919, he opened the Rankin School of Flight in Oregon and formed the Rankin Air Circus. In 1929, he was the first to fly nonstop from Canada to Mexico; in 1931, he set a record of 131 consecutive outside loops; and in 1937, he won the International Aerobatic Championship. During World War II, he established the Rankin Aeronautical Academy, which trained over 10,450 Army Air Force cadets. (WL.)

This Boeing P-12E was one of three assigned to the Army Air Corps reserve and housed in one half of Hangar No. 1 at Oakland Airport in 1939. The normal training was done in new North American BT-9C trainers, so the opportunity to fly this 1932 version of the navy's F4B-4 was very popular. Instrument training was done in an old Douglas BT-2BI. (WL.)

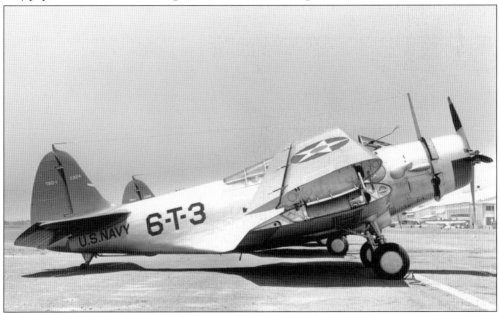

Oakland was the scene of many visiting navy aircraft from Naval Air Station San Diego, including this new Douglas TBD-1 from Torpedo Squadron Six. The chance to see this new plane with its then-secret folding wings was made possible because of the naval-reserve facilities at Hangar No. 3. Fleet squadrons of 18 planes each would often come to Oakland on weekend training flights, scheduled so that members of the crew who wanted to could go watch football games at the University of California. (WL.)

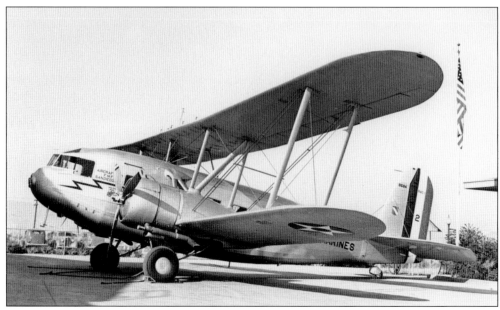

The U.S. Marine Corps also flew planes from San Diego, such as this Curtiss R4C-1 Condor transport from Aircraft One, Fleet Marine Force. It is parked here between the open hangar doors and the exhibit building in May 1939. (WL.)

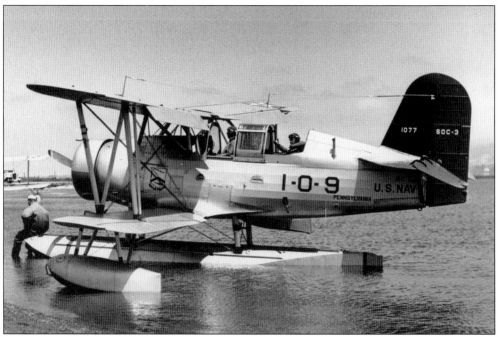

A much rarer occurrence was the visit by battleship floatplanes. In July 1938, the Curtiss SOC-3s from the section of VO-1 aboard the USS *Pennsylvania*, which included the SOC-3 for the commander in chief of the U.S. fleet, came for a short stay. These planes often visited Oakland while fitted with wheels instead of floats. (WL.)

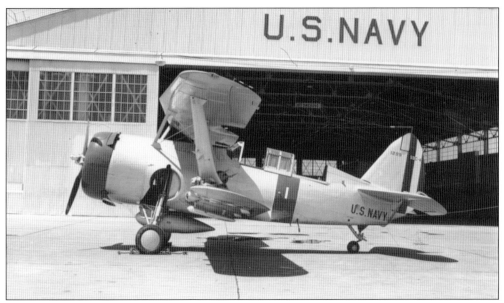

Curtiss SBC-4, Oakland No. 1, is pictured in front of a clean Hangar No. 3, used by the U.S. Navy and U.S. Marine Corps reserve from the time it was built. It had metal doors built as a ship's bulkhead to some of the rooms in the front of the hangar. Some SBC-4s were taken away from the reserves to go to France and were towed across the Canadian border on a technicality used to avoid the Neutrality Act. (WL.)

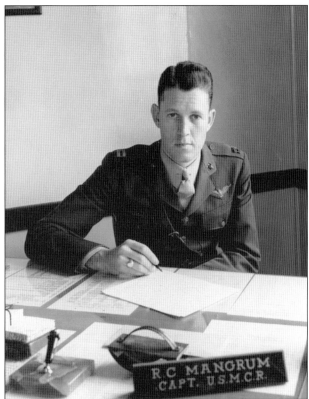

Capt. Richard C. Mangrum, executive officer of Naval Reserve Aviation Base Oakland, and commanding officer of the U.S. Marine Corps reserve there, became assistant commandant of the U.S. Marine Corps after World War II. (RC.)

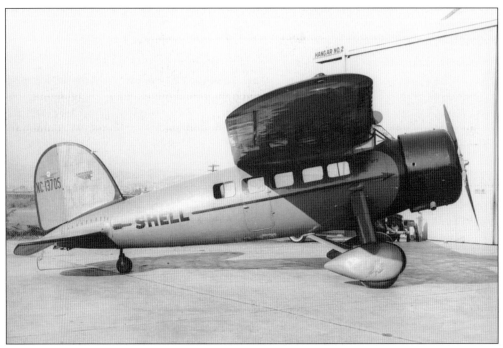

This Lockheed Vega 5C at Oakland in 1939 is typical of many aircraft that were owned by oil companies, who were proud to have their name displayed. Painted in Shell colors, this Vega is No. 7 in a fleet operated by their aviation department. (WL.)

Another beautiful company plane is pictured here at the San Francisco Bay Airdrome in 1939. This Stinson SR-9F Reliant was owned by the Mohawk Petroleum Corporation. (WL.)

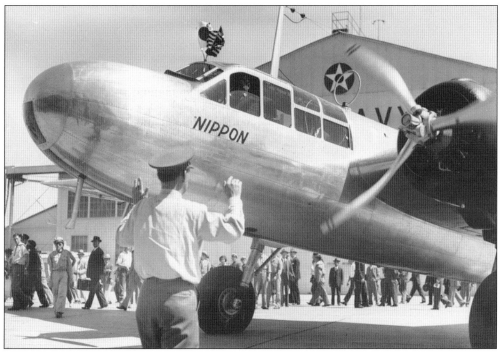

The Mitsubishi G3M2 is shown arriving on September 2, 1939, at Oakland, where it was taxied into Hangar No. 4 and put under guard. Named *Nippon*, it was a new Japanese-navy bomber modified to carry a crew of six on a round-the-world goodwill flight sponsored by two Japanese newspapers. It left the next day for Los Angeles. England declared war on Germany on September 3, when Poland was bombed, so the flight was almost cancelled. However, with some changes in the route, *Nippon* continued and landed back in Japan on October 20, after flying 32,846 miles in 55 days. (WL.)

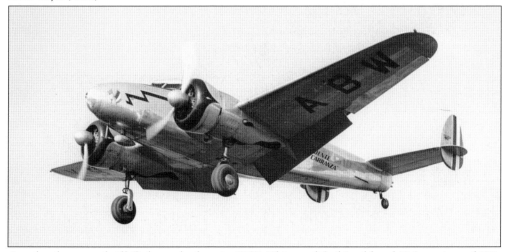

Another long goodwill flight took place in 1940. This modified Lockheed 12A, registered XB-ABW and named *Presidente Carranza*, was flown to Oakland for the start of a 20,000-mile tour of Central and South America. Scheduled to leave on the opening day of the 1940 fair on Treasure Island, and piloted by Maj. Antonio Cardenas, it left Oakland on May 24 on a nonstop flight to Cerro Loco, Mexico. It arrived back in Mexico City from Cuba on September 13. (WL.)

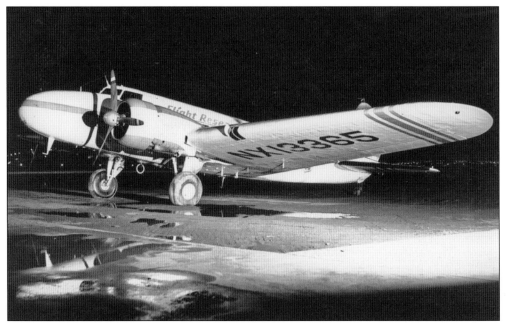

United Air Lines modified one of their Boeing 247Ds as a flight-research plane and flew it for many hours, testing radio communications, absolute altimeters, wind-velocity recorders, range finders, and other instruments. Painted white with red trim, it is seen here in a special nighttime photograph at Oakland Airport in November 1940. (WL.)

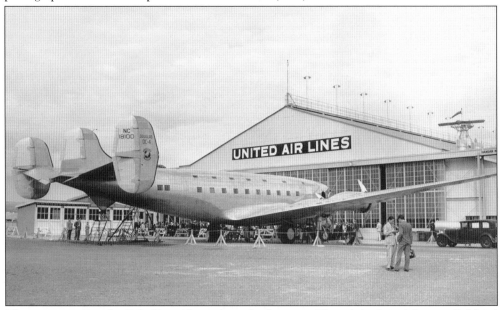

The giant new Douglas DC-4E was flown from the factory to United Air Lines's base at Oakland Airport before leaving on a publicity tour. This photograph was taken the next day, May 20, 1939, during a press interview. After major changes, the design became the wartime C-54 and postwar DC-4. This prototype was sold to Japan, dismantled with the help of students from the Boeing School of Aeronautics, and the fuselage loaded on a Haviside Company barge on September 29. It was then towed from the airport lagoon to a Japanese freighter in the bay. (WL.)

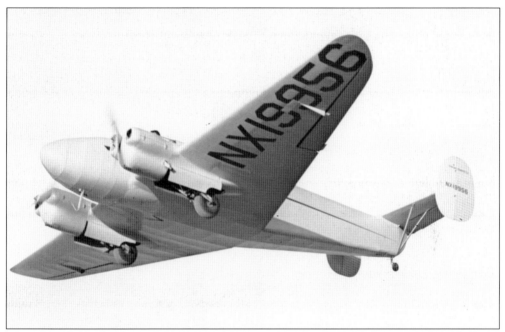

The Edwards XMBM-1 was a new design for a two-place, twin-engine private plane built by the Sterling Edwards Company of San Francisco in 1938. It was frequently seen at Oakland and Palo Alto Airports. This June 1939 photograph shows the two 50-horsepower Continental engines and retractable landing gear. (WL.)

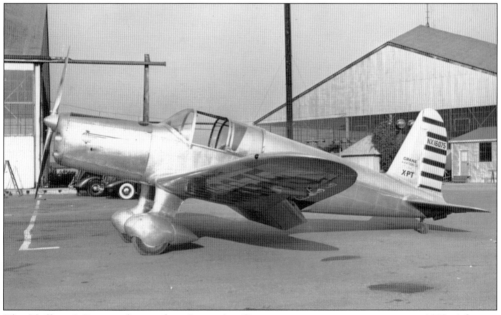

The Phillips 1-C was submitted to Army Air Corps tests as a primary trainer in 1939. After its return to Van Nuys, it was repainted and used in the movie *House Across The Bay* with Walter Pidgeon, Joan Bennett, and George Raft. On the tail is the name of the fictitious airplane company in the movie, "Crane Aviation Co." This photograph was taken at the San Francisco Bay Airdrome. (WL.)

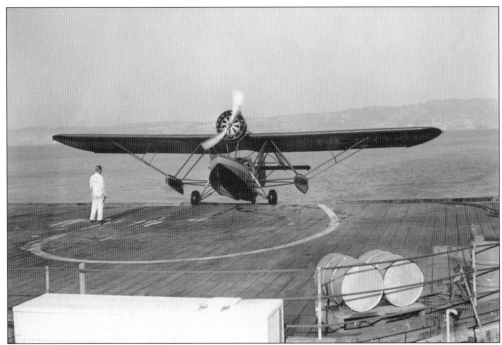

Sikorsky S-39A, NC-804W is shown coming out of the water at the Paul Mantz Seaplane Base on the east side of Treasure Island in 1939. Scenic flights were available in this plane and an S-38 during the Golden Gate International Exposition in 1939 and 1940. (WL.)

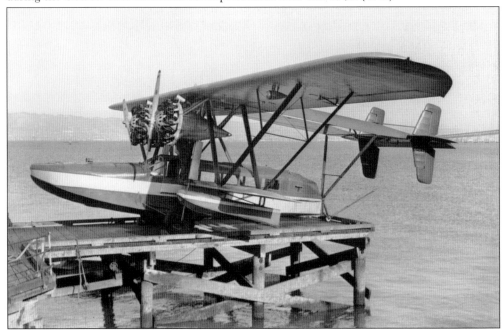

Sikorsky S-38C, NC-158H, is parked on the south extension of the Paul Mantz Seaplane Base. Souvenir tickets for flights in this plane stated, "M . . . has flown over the Golden Gate—Alcatraz—World's Greatest Bridges—San Francisco and has seen Treasure Island in all its beauty from the air in one of our giant twin-motor amphibians." (WL.)

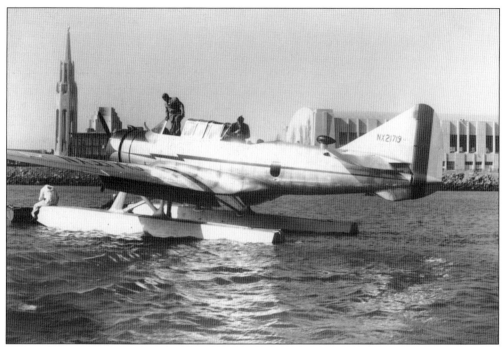

This Vultee V-11GB2F Attack bomber of the Brazilian Air Force landed on the bay and taxied into the Treasure Island lagoon opposite the Pan American Airways hangar. It flew over the island, dropped some Brazilian earth, and made a shortwave-radio broadcast to Brazil as part of the ceremonies for South American Day in the summer of 1939. (LC.)

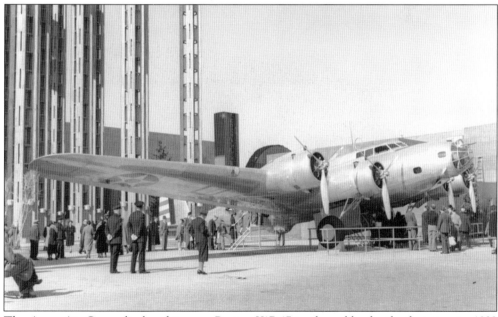

The Army Air Corps displayed its new Boeing Y1B-17 to the public for the first time in 1939 outside the Federal Building on Treasure Island. It was repainted in wartime camouflage and put on exhibit again in 1940 during the second year of the fair. The Air Corps newsletter claims that 1.6 million people went through it and an estimated five million people saw it. (WL.)

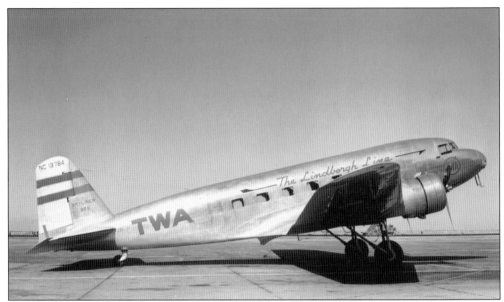

The Douglas DC-2 revolutionized airliner travel and led the way for the famous DC-3. TWA was a major operator of the DC-2 and flew it under the name "The Lindbergh Line," as can be seen in this photograph of NC-13784 taken in San Francisco in June 1939. (WL.)

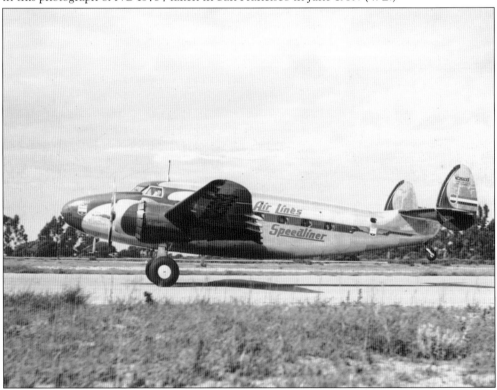

The rarest United Air Lines type used during this period was the Lockeed 18 Lodestar. Called "Speedliners" by United, four were flown between San Francisco and San Diego. Shown here is NC-25633, named *City of Alameda*. This photograph was taken in April 1941. (WL.)

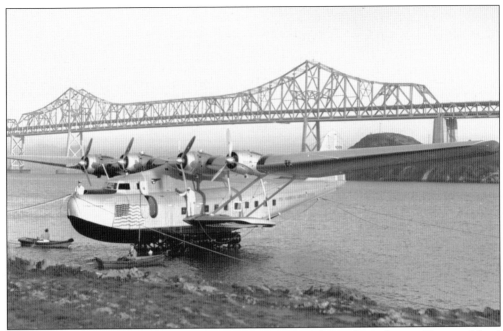

Probably the most famous flying boat of all time, the *China Clipper*, shown here at Treasure Island in 1939, symbolizes the opening of the Pacific Ocean to airline travel. First flown from the Pan American Airways base at Alameda, it moved to Treasure Island for the opening of the exposition. Four of these Martin 130s were built for the Pan American Airways System and contrary to popular opinion, only one, NC-14716, was named the *China Clipper*. (WL.)

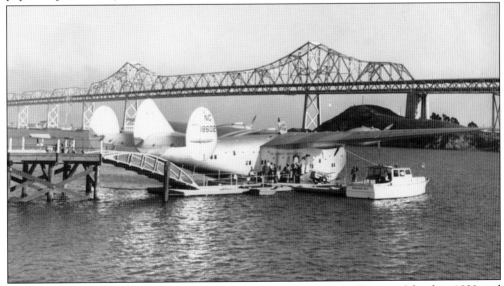

The Boeing 314As, built to Pan Am specifications, were seen on Treasure Island in 1939 and 1940. This photograph shows the passenger ramp for boarding with the San Francisco–Oakland Bay Bridge in the background. The small boat is PANAIR XI-P. The planes were brought out of the water on a movable cradle on rails and serviced in two large hangars. One of these had an interior mezzanine level as part of the exposition so that visitors to the fair could watch the operations in the hangar. (WL.)

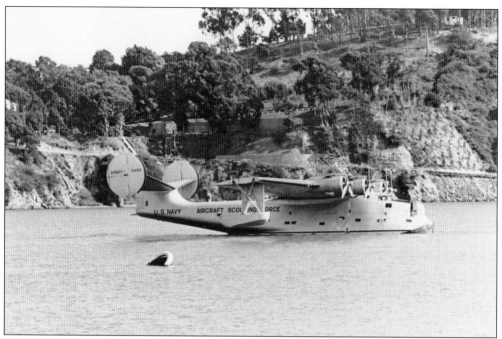

A very special visitor to the Treasure Island lagoon was this Consolidated XPB2Y-1 of the Aircraft Scouting Force. It was used to fly Secretary of the Navy Frank Knox to Hawaii on September 7, 1940. There were very few four-engine flying boats available at this time, so this experimental patrol bomber was used as a staff transport as was the Sikorsky XPBS-1. Admiral Nimitz and some of his staff were aboard the XPBS-1 when in crashed in the bay upon its arrival from Hawaii on June 30, 1942. (WL.)

This new Taylorcraft BC12-65 landed on Lake Merritt in Oakland in 1941. Some of the downtown buildings can be seen in the left background. Forrest "Iron Hat" Johnson, dressed as Santa Claus, landed his Aeronca C-3 on floats on the lake in the 1930s. (WL.)

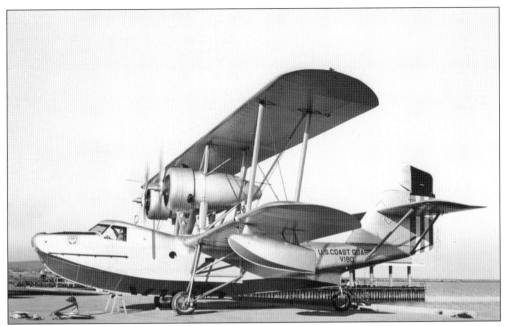

Two Hall-Aluminum PH-3s were assigned to the San Francisco Coast Guard Air Station in 1941. These were flying boats, and the wheels in the photograph are part of a removable beaching gear. (WL.)

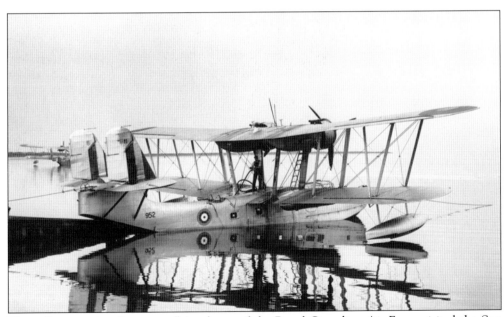

Three Supermarine Stranraer flying boats of the Royal Canadian Air Force visited the San Francisco Coast Guard Air Station on November 26, 1941. No. 952 is tied to the seaplane ramp, and another is in the left background. (WL.)

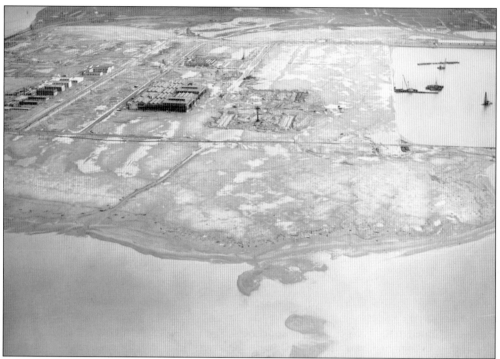

An early 1940 aerial view shows Naval Air Station Alameda being built. The row of hangars is just being started in the center, and the seaplane lagoon is being formed on the right. (WL.)

The North American AT-6A from Mather Field sits in front of the giant Hangar No. 1, built for the USS *Macon* at Moffett Field. This photograph, taken on March 7, 1942, is one of the last to show Army Air Corps planes based on the field. The Army Air Corps took over Moffett Field on October 25, 1935, and it was returned to the U.S. Navy on April 20, 1942. (WL.)

This Waco UPF-7 shows the special markings required after December 8, 1941, when all private flying was banned in the West Coast War Zone. Because it was being used in the national Civilian Pilot Training Program, it was allowed to fly with the letters "U.S." and the national-star insignia added. The CPTP was an excellent quasi-military program, and Dave Bridges, in the cockpit, went directly from this CPTP secondary to Pan American Airways. The photograph was taken at Belmont Airport on December 23, 1941. (WL.)

Author William T. Larkins is shown here in August 1941 with one of the Luscombe 8As used in the CPTP. The primary course consisted of 39 hours with a private pilot's license issued at the conclusion. The course, with a five-unit ground school class at San Francisco Junior College, was so strict that the CAA allowed all 39 hours to be logged as solo time. (LC.)

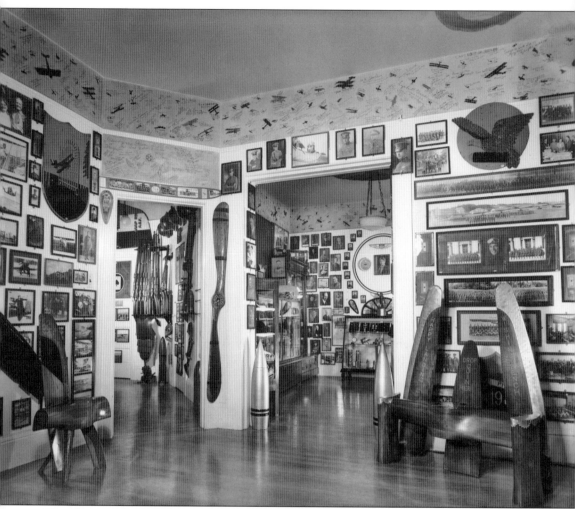

This photograph shows part of the interior of "The Hangar, Shrine of the Air," a small house turned into an aviation museum by Mary E. "Mother" Tusch. She opened her home to aviation cadets at UC Berkeley in World War I, and it was continually added to over the years, including the autographs of visiting pilots, which can be seen at the top of the photograph. The houses on the street were demolished to make room for the campus student union and cafeteria after World War II, but everything in the museum was carefully removed under the direction of Paul Garber and sent to the Smithsonian for the National Air and Space Museum with the intention of reassembling it there. A five-cubic-foot file of records, scrapbooks, and photographs is on file at the NASM. (RC.)

Five

WORLD WAR II

The Japanese began the Pacific war with an attack on Pearl Harbor in Hawaii on December 7, 1941, at 7:55 a.m. Eight hours later, the U.S. Army Air Force bases in the Philippines were attacked, allowing the Japanese to take the islands relatively unopposed. The Japanese success was overwhelming but not complete. Americans were now united in their desire for war and revenge.

The United States made a quick recovery from the debacle of Pearl Harbor. On April 18, USAAF Lt. Col. "Jimmy" Doolittle led a fleet of carrier-launched B-25s on a bombing raid over Tokyo. The daring raid, although inflicting only minor damage, raised American spirits. In Japan, the shocked Imperial Navy began to change its strategy, realizing that the U.S. fleet was still capable of attack.

The Bay Area in 1942 became a major staging port for men and material going to the Pacific and became a beehive of activity. Six fighter squadrons and one tactical reconnaissance squadron of the Army Air Force were stationed at Oakland Airport at various times between December 8, 1941, and April 1944. They used Curtiss P-40s and Bell P-39s, and one fighter squadron may have used Lockheed P-38s. All of the fighter squadrons would eventually be transferred to combat areas overseas during the war.

In 1943, the U.S. Army assumed maintenance costs, and Oakland became the marshaling point for all planes bound to U.S. forces in the Pacific. Commercial flights were routed to San Francisco. This made a huge difference in the future development of the respective airfields because San Francisco built accommodations for commercial service all during the war and prospered with the always-expanding air traffic and the forced diversion from Oakland. The Dade Company, headquartered at Mineola, New York, located one of its branches at Oakland on August 9, 1943, and crated and shipped hundreds of military aircraft overseas. It occupied five hangars at one time. As of December 1, 1944, Oakland was assigned to the Pacific Overseas Air Technical Service Command. The airport was leased by the war department and was shared with the U.S. Navy.

After the war was over, San Francisco Airport continued to prosper with civilian airlines, while Oakland phased down as the military rapidly reduced its activities. Had it not been for this turn of events, no doubt Oakland would now still be the major air terminal in the Bay Area.

The silver Coast Guard planes at the San Francisco Coast Guard Air Station were quickly repainted after the 1941 Pearl Harbor attack. This photograph of one of the old Douglas RD-4s was taken on June 3, 1942. It shows the centerless stars that were adopted on the theory that any red seen on a plane in these nervous times would indicate that it was Japanese. (WL.)

Lockheed P-38s of the 83rd Fighter Squadron were assigned to Mills Field (San Francisco Municipal Airport) from May 10 to June 23, 1942. Earth revetments were hastily built on the field, and airline operations were limited. (LC.)

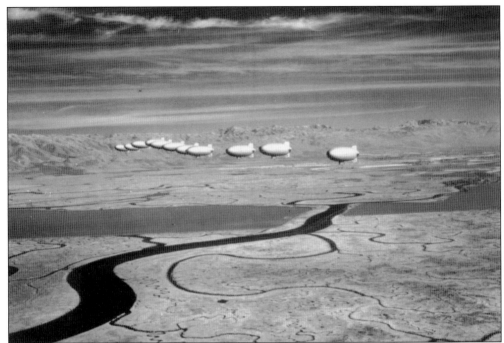

Moffett Field was quickly turned into a lighter-than-air training field. Both small gondola balloons and larger Non-Rigid L Type airships such as these were used for LTA pilot training. The Naval Reserve at Oakland had two Lighter-Than-Air Squadrons after World War II, and the Goodyear Blimp *Volunteer* was seen often in the Bay Area in the late 1930s. (RC.)

The increase in air traffic at Naval Air Station Alameda required the establishment of satellite fields for advanced training. This Grumman F6F-3 is taking off from Outlying Field Concord in October 1943. The field was used for practice landings of operational aircraft from Alameda. Naval Reserve Aviation Base Oakland became a primary flight-check operation and at one time had 146 Stearman N2S trainers. (WL.)

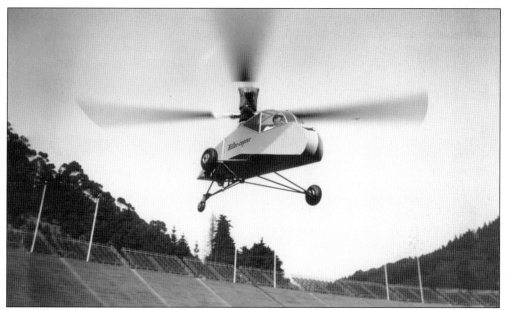

On July 4, 1944, the first successful coaxial helicopter flight in the United States was made by Stanley Hiller Jr. in Memorial Stadium at UC Berkeley in the helicopter that he built, the XH-44. Hiller made the first public flight in this aircraft at the San Francisco Marina Green on August 30, 1944. Hiller was a highly creative inventor and businessman, as was his father before him. Stanley Hiller Sr. had built and flown airplanes in Alameda and San Francisco in 1909–1913. Young Hiller created a successful helicopter-manufacturing business, Hiller Industries, in 1940. Founded in Oakland in 1942, the company relocated to Berkeley in 1944, back to Oakland in 1945, back to Berkeley, then to Palo Alto near Stanford University in May 1946, and finally to Willow Road in 1948, where it remained for the next 20 years. It is believed that Hillers' company produced more helicopters than any other manufacturer in 1949 and 1950. More than 600 Hiller helicopters were stationed at one army base alone in the 1950s, and over 3,000 Hiller helicopters were produced at the Palo Alto site. (RC.)

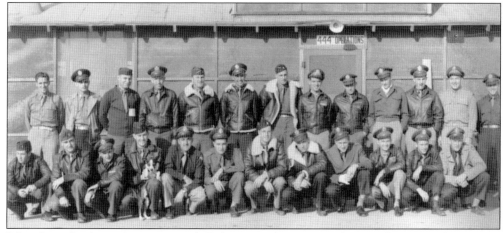

Pilots from the Army Air Force 444th Fighter Squadron pose in front of the Concord Army Air Field Administration Building. The 444th was stationed there from September to December 1943, and the 329th Fighter Squadron was there from December 1943 to March 1944. Both squadrons flew the Bell P-39 Airacobra for advanced operational training. (DC.)

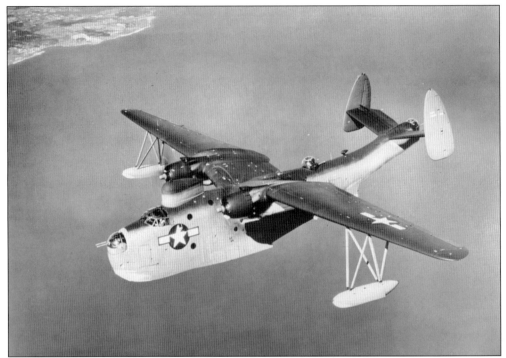

The Martin PBM Mariner operated out of NAS Alameda for most of World War II, both as a patrol bomber and as a transport. Fleet Air Wing Eight had 14 PBM-3R transports at Alameda in 1944. This photograph shows a PBM-5 patrol version. (LC.)

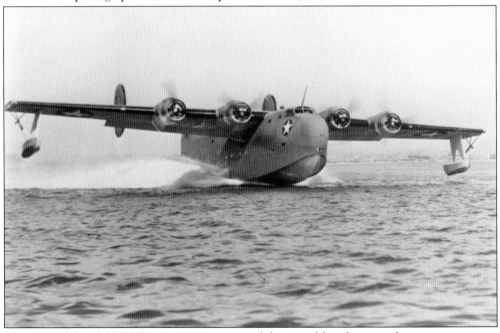

The Consolidated PB2Y-5R transport version of the patrol bomber was the primary type to fly passengers and cargo from San Francisco to Honolulu in World War II. In December 1944, Transport Squadron Two at Alameda had 41 of these assigned plus five older PB2Y-3Rs. (LC.)

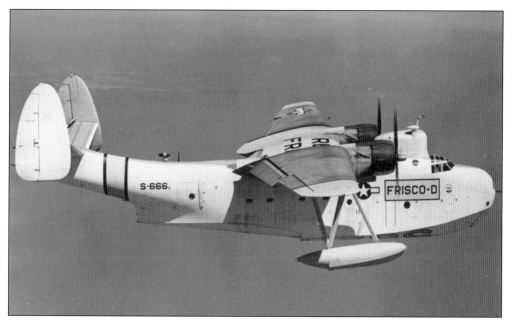

The Coast Guard, part of the U.S. Navy in wartime, also flew Martin PBMs in the Bay Area. This PBM-3S was modified for search and rescue missions and was flown from the Coast Guard Air Station at San Francisco Airport.

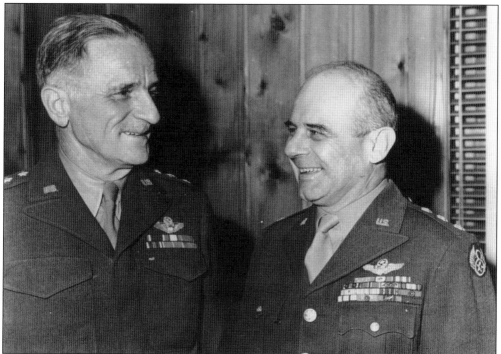

In World War II, Gen. "Tooey" Spatz, commander of all American air forces in Europe, is pictured here with Maj. Gen. "Jimmy" Doolittle, one of the most noted and accomplished aviators of all time. Spatz served at Crissy Field in the 1920s. Doolittle was born in Alameda and attended UC Berkeley. (RC.)

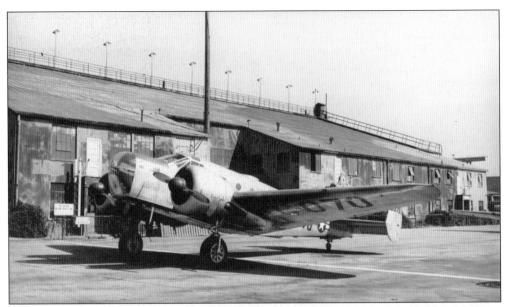

This Beech AT-11 bombardier trainer is parked in front of Hangar No. 3 at Oakland Airport on October 19, 1946, and the photograph shows the wartime camouflage paint that has not yet been removed. The 50th, 68th, 79th and 84th Fighter Squadrons flying P-40s were based at Oakland in 1942, and the 160th, 329th, and 393rd Fighter Squadrons flying P-39s were there in 1943. (WL.)

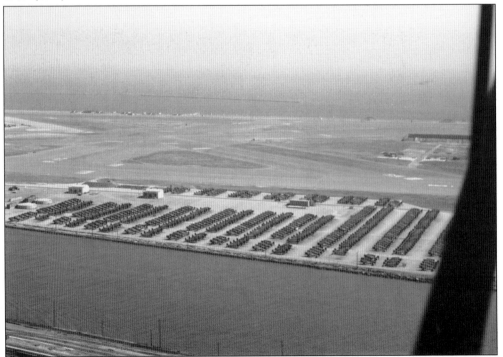

Disposal as salvage or storage of aircraft was a major problem at the end of World War II. This May 1947 photograph of Naval Air Station Alameda shows rows of Grumman F6F fighters and TBM torpedo bombers being saved for use by the naval reserve. (WL.)

Surplus World War II trainers and light aircraft were sold by the War Assets Administration at the end of the war. Prices were so low, such as $875 for a Stearman PT-17, that there were more buyers than available planes. This photograph shows a WAA sale in 1946 at Buchanan Field, where a drawing had to be held to decide the purchasers. (LC.)

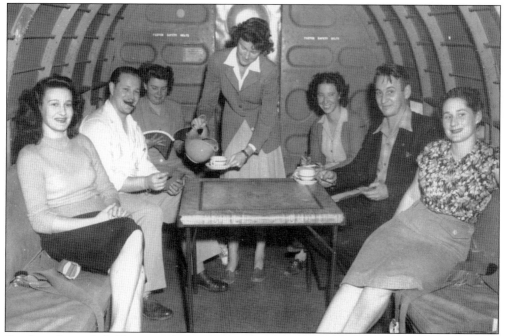

Surplus sales included large airplanes, such as this Douglas C-47 put into immediate service by SSW, Inc., of Concord for scenic flights over Yosemite Valley. The military side seating was still in use to go with serving tea on a card table. (LC.)

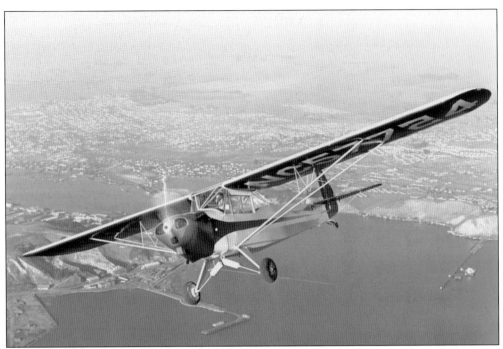

This Taylorcraft L-2M is typical of the surplus light military planes for sale in 1946 for $750. After a safety check and some fresh paint, they became fine personal aircraft. This L-2M is being flown over Suisun Bay in November 1946 by Ken Trahan. (WL.)

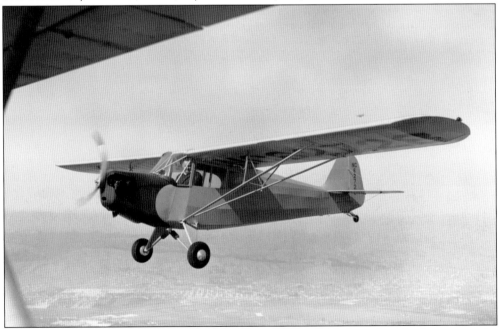

When the war started, there was a need for training gliders, so Taylorcraft and other companies modified their light aircraft to serve the purpose. Because it was then so easy to rebuild a TG-6 glider back to a light plane, there were several, such as this one done by Marston and Keyes at Hayward Airport. It is shown here being flown by Red Turner in May 1946. (WL.)

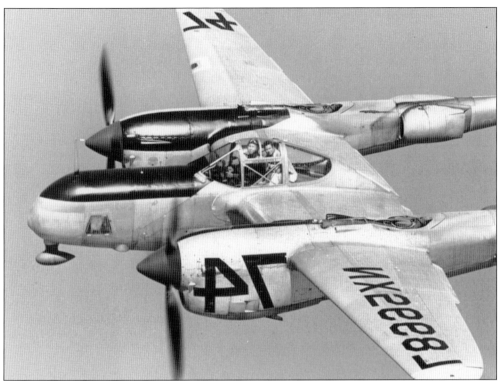

High-performance fighters were also sold, such as the Lockheed F-5G P-38 pictured here, which was selling for $1,250, a lower price because of the cost of operating two engines. Bill Lear Jr., shown here with aerobatic pilot Betty Skelton along for the ride, bought this plane to enter the 1947 cross-country Bendix Race. The photograph was taken over San Francisco Bay in August 1947. (WL.)

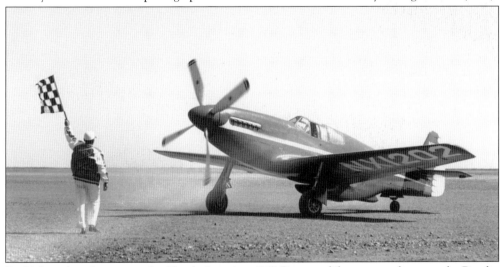

Paul Mantz bought two surplus North American P-51Cs to modify as racers that won the Bendix Race three times. This photograph shows his arrival at Oakland on August 16, 1947, after setting a speed record for Burbank to Oakland in 51 minutes 56 seconds. The next day, he set another record returning from Oakland to Burbank in 50 minutes 40 seconds. Both records had been set earlier by San Francisco pilot Frank Fuller Jr. in 1939 with a modified Seversky SEV-S2. (WL.)

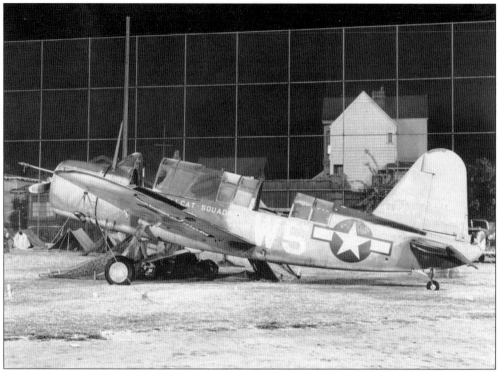

This Vought OS2U-3 was on loan by Scout Observation Service Squadron Three at NAS Alameda to "Air Scouts Hellcat Squadron 7." It was used as part of this overnight encampment in Lincoln Park in Alameda in May 1947. Small tents can be seen in the left background. (WL.)

This 1946 aerial view shows Concord AAF base after it was returned to Contra Costa County with its improvements after the end of the war. It was formally dedicated as Buchanan Field on August 4, 1946. The view is to the northeast, showing the open land around the airport at that time. (WL.)

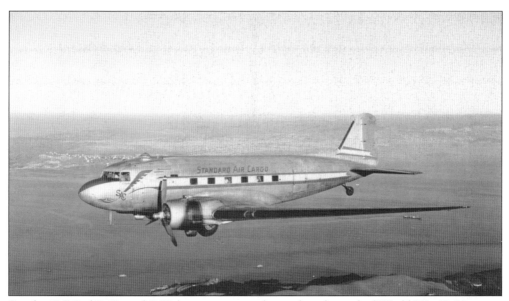

Surplus DC-3s (C-47s and R4Ds) were in great demand at the end of World War II. Veterans started many new "airlines," some with only one airplane. In addition there was an increased interest in flying cargo. This unique photograph shows a former C-47 owned by Standard Air Cargo of Seattle flying on one engine in January 1948. It was not a problem; it was just a special pose for the photographer. (WL.)

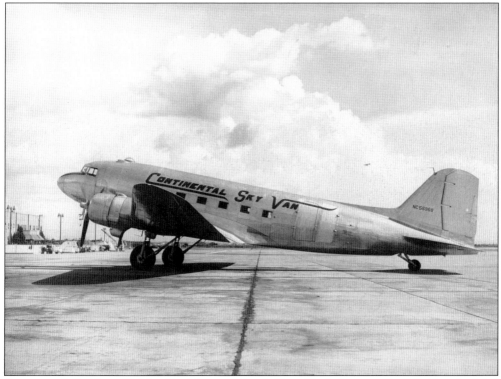

Continental Sky Van of Oakland had three surplus C-47s and had plans to add a DC-4 for scheduled passenger service when this photograph was taken at Oakland in March 1946. (WL.)

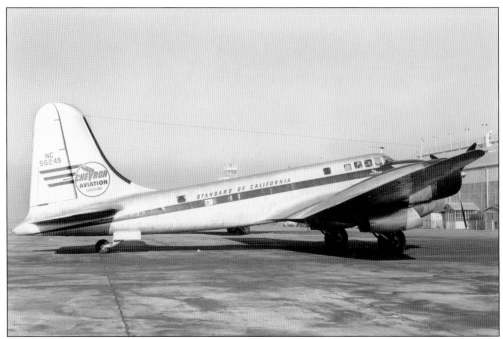

Surplus military bombers were purchased by several companies to become executive aircraft. This Douglas B-23 owned by Standard Oil of California, at Oakland in January 1948, is one example and others were B-23s owned by Union Oil and General Electric. (WL.)

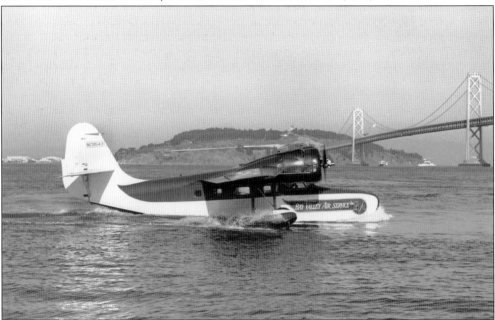

Three surplus Grumman JRF-6Bs, returned from lend-lease to England, were purchased by the newly formed Bay Valley Air Service to start a commute service from San Francisco to Sacramento. This unique airline started in the water at the Ferry Building and ended on land at the Capitol Skypark. This photograph shows one with Yerba Buena Island and the San Francisco–Oakland Bay Bridge in the background. (WL.)

Six

POSTWAR AND THE JET AGE

World War II, like World War I, greatly accelerated and advanced aviation technology and the application of these advances. Need, determination, and congressional appropriations provided the impetus for the expansion of the use of airplanes to out-build, out-maintain, and outdo the enemy. A huge increase in trained manpower to carry out the military need provided the manpower needed after the war to continue the expansion in the civilian sector. As the airline industry began to take shape between the world wars, aircraft manufacturers scrambled to identify just what opportunities the new travel market might offer and to produce more sophisticated machines. Generally speaking, this meant developing faster, bigger, safer, and more comfortable airplanes. Airplane manufacturers built new airplanes with pressurized and heated cabins. Suddenly airplanes could fly above bad weather and mountains, where the air and thus the ride were smoother. In 1940, three million Americans flew. By 1956, 55 million flew.

In 1946, the old Oakland Airport Inn was converted to offices for non-scheduled air-freight and passenger lines operated mostly by ex-servicemen flying war-surplus planes. Passenger traffic at Oakland Municipal Airport was up 83 percent over the previous year with 58 daily scheduled flights. On August 23, 1954, a new, ultra-modern, six-story, $14 million terminal was opened at the San Francisco International Airport. The airport has been expanded many times since.

Following World War II, the process of innovation not only continued but also accelerated due to the invention of the jet engine. The first American jet airliner, the Boeing 707, was introduced in 1959. It cut flying time between New York and London from 12 hours to 6 hours. Crossing the Atlantic Ocean had until recently required spending six days on a ship. By 1965, ninety-five percent of transatlantic travelers were crossing in the fast jets of Pan Am and European airlines, such as British Overseas Airways.

In the 1970s and 1980s, a few visionary people began to open the skies to the average American with low fares. Since 1938, the federal government had strictly regulated airline fares and routes. In 1978, Pres. Jimmy Carter and Congress changed the situation drastically when they deregulated the airlines. Airlines could now choose their own routes and fares. By the mid-1990s, the U.S. airline industry had bifurcated. First, there was the informal cartel of high-cost, large-network carriers such as American and United Airlines. Second, there was the low-fare airline industry, of which Southwest, JetBlue, and AirTran are now major players. Low-fare airlines vastly increase enplanements at airports nationwide, where the cartel would charge much higher fares.

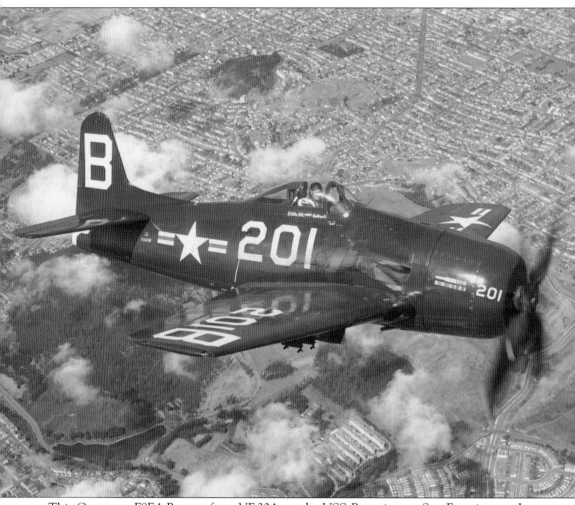

This Grumman F8F-1 Bearcat from VF-20A on the USS *Boxer* is over San Francisco on June 2, 1947. This is the commanding officers' aircraft and has Lt. Cmdr. D. C. Caldwell's ribbons painted on the cowling. (WL.)

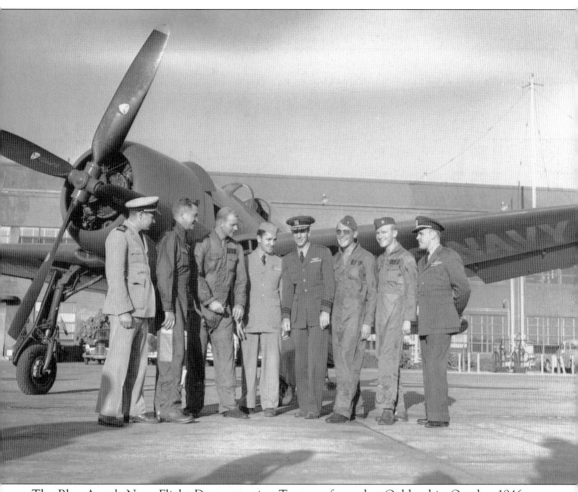

The Blue Angels Navy Flight Demonstration Team performed at Oakland in October 1946. The four pilots in flight suits are, from left to right, Lieutenant Barnitz, Commander Voris (team leader), Lieutenant Wickendoll, and Lieutenant (jg) May. They are posed with officers from NAS Oakland. (WL.)

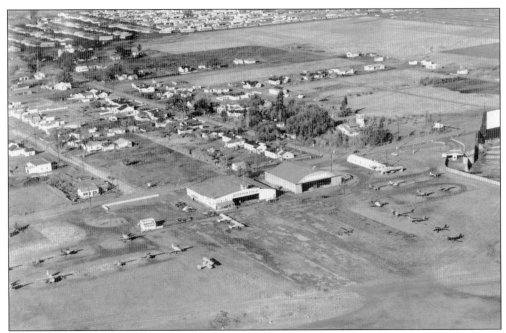

This photograph gives a postwar aerial view of Sherman Field at Pleasant Hill. It was opened in May 1941 and closed in late 1951 to make room for the new 680 Freeway. Unlike the other local private airports that were closed during World War II, this one was used by Pan American for instrument flight training with a Waco VKS-7 and two Stinson Reliants. (LC.)

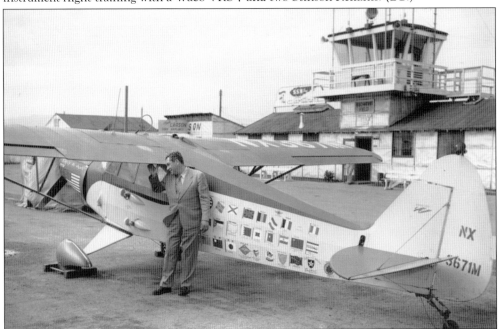

George Truman is pictured here with one of the two Piper PA-12s that he and Clifford Evans flew 25,000 miles around the world in 1947. It is in front of the old Concord AAF administration building and shows the wartime control tower used by the AAF. It was not continued in use when Contra Costa County operated the field. (LC.)

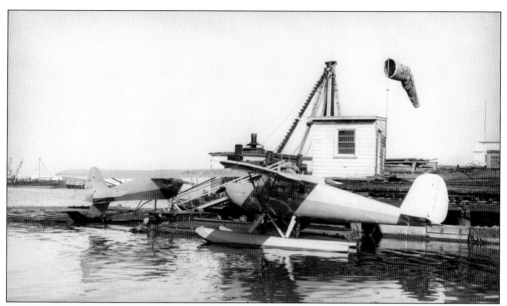

The Norton Marine Air seaplane base at the foot of Webster Street in Oakland is shown as it appeared in 1947. Norton operated three floatplanes, offered flight instruction and charter service, and had provisions for visiting aircraft. (WL.)

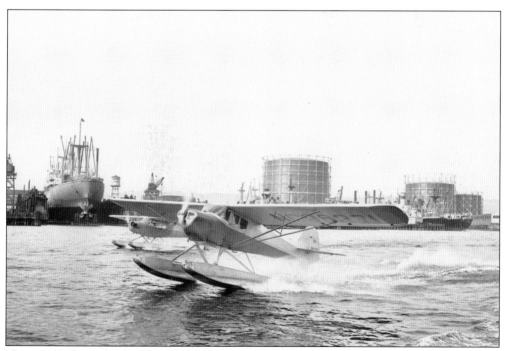

Norton's Taylorcraft BC-12D and Piper J-3C pose for a publicity photograph by making a high-speed taxi down the Oakland Estuary past some of the industrial area on April 19, 1947. (WL.)

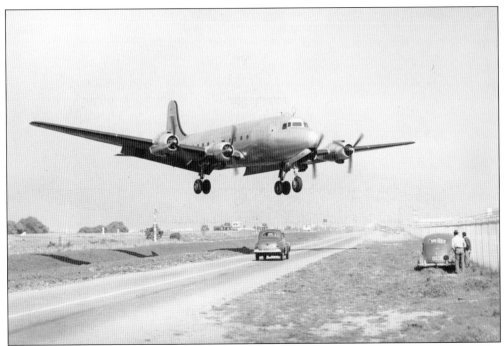

Pan American Airways Douglas DC-4, NC88943 is shown landing low at San Francisco over the Bayshore Highway and airport road on March 26, 1947. This was one of several C-54Gs leased from the AAF for crew flight training, not for passenger service. (WL.)

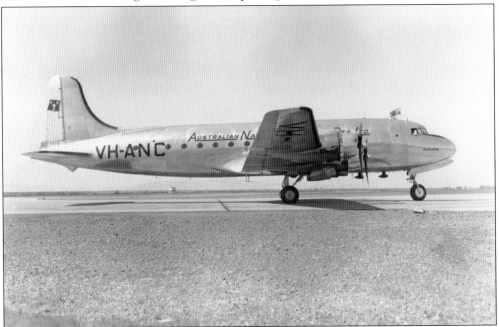

Douglas DC-4, VH-ANC, is pictured as it arrives at Oakland on September 18, 1946, for the first flight of Australian National Airways to the United States. The plane had to continue on to Vancouver to disembark the passengers because the airline landing rights had not yet been granted. (WL.)

A Lockheed P2V-3C of squadron VC-5 is shown landing at Moffett Field in November 1948, three months after the squadron was commissioned. (WL.)

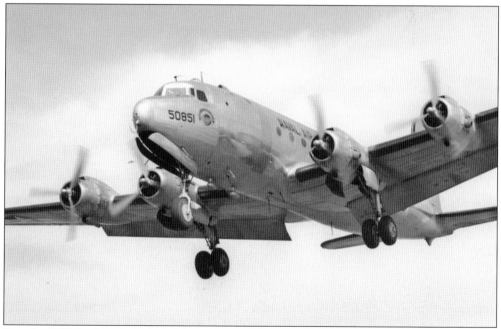

Douglas R5D-2 of the Naval Air Transport Service is pictured landing at Moffett Field in May 1946. Navy transport squadrons VR-3, VR-4, and VR-5 operated these C-54-type aircraft for passenger and cargo service to Hawaii for several years after the end of the war. (WL.)

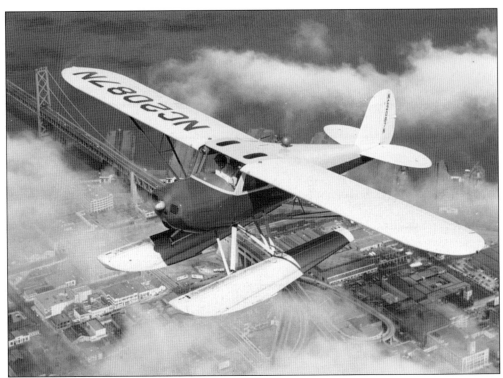

Norton Marine Air's float-equipped Cessna 120 flies over San Francisco and the automobile approaches to the San Francisco–Oakland Bay Bridge in May 1947. (WL.)

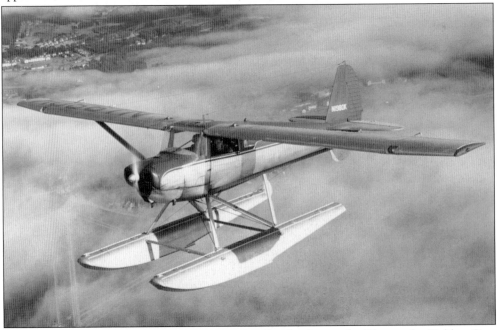

Pilot, author, and aviation historian Peter Bowers flies his Luscombe 8E over the Golden Gate Bridge on July 13, 1949. Pete flew this floatplane around the United States to prove that it could be done. (WL.)

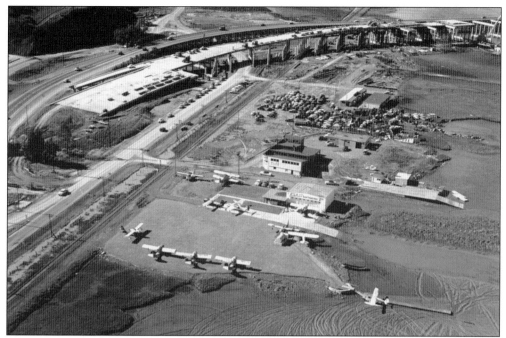

The Commodore Seaplane Base near Sausalito was the center for private seaplane activity in the Bay Area for many years. This aerial photograph shows eight Republic Seabees as well as a Luscombe, a Grumman Widgeon, and a rare Grumman J2F-6. (LC.)

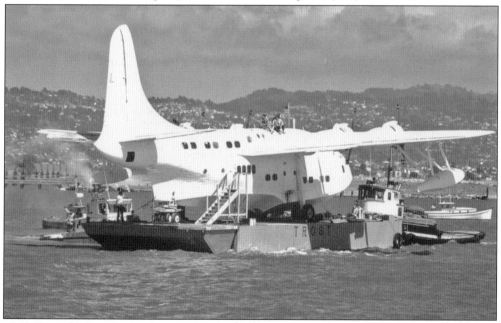

The Short Solent III, N9946F, made its final trip across the bay from Richmond to Oakland Airport on a Trost Moving Company barge in August 1987. This was its third time on the bay, as it had landed there on the water after arriving from Honolulu in May 1955. The barge stopped briefly in the Treasure Island lagoon with the Solent. The last seaplane to land and taxi into the lagoon was Lynn Hunt's Grumman HU-16 in July 1997 for a Pan Am celebration. (WL.)

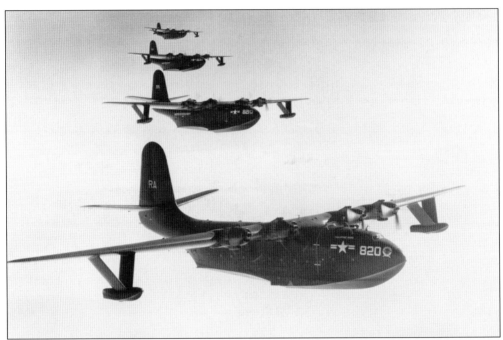

The Martin JRM "Mars" series of flying boats operated between Alameda and Honolulu, as well as up and down the West Coast. On May 19, 1949, the *Marshall Mars* set a record for carrying 301 passengers and a crew of seven from Alameda to San Diego. The *Caroline Mars* was brought ashore and put on exhibit as part of the San Francisco Air Fair in 1948. A Mars flying boat was stored on land at San Francisco Airport after being sold surplus by the U.S. Navy and while awaiting flight to Canada by its new civilian owners. (RC.)

The Mars flying boats were replaced by the Consolidated P3Y-2 Tradewind passenger-cargo flying boats in 1956. Four were delivered to VR-2 at NAS Alameda and operated until 1958. The *Indian Ocean Tradewind* set a record on October 18, 1956, flying from Honolulu to Alameda in six hours and 45 minutes. This photograph shows the *Caribbean Sea Tradewind* at Alameda in October 1956. (PB.)

The rare Lockheed XR6O-1 Constitution is shown landing at Moffett Field in 1949. On February 3, it flew from Moffett to Washington, D.C., with 78 passengers and 14 crewmembers, to set a new record in nine hours and 35 minutes. (WL.)

This surplus Consolidated RY-1 (the navy version of the C-87A) is shown here on the ramp at Oakland on February 28, 1948, ready to leave the next day for China. Named *The Explorer*, it was a joint venture between Milton Reynolds and the Boston Museum to survey and photograph the Yellow River and the Amne Machin mountains. Bill Odom was the pilot, with Tex Sallee as flight engineer, and the passengers included museum and university specialists. (WL.)

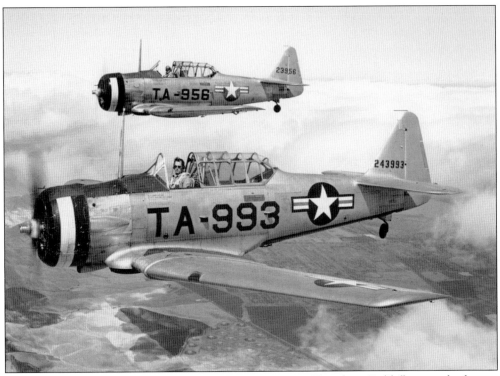

Two North American AT-6Cs of the air force reserve at Hamilton Field fly over the bay in August 1947. (WL.)

Northrop P-61B, 42-39600, from Hamilton Field flies over San Francisco Bay in June 1948. These late World War II night fighters were replaced by North American F-82Fs, and a squadron of these was based at Hamilton in the same year. (WL.)

Fairfield-Suisun Army Air Field was home to several B-29 squadrons, and it was renamed Travis Air Force Base after General Travis was killed in a B-29 taking off from the field in August 1950. During this time, it was under the Strategic Air Command flying B-29s, B-36s, and B-52s. This B-29 of the 388th Weather Recon Squadron was photographed there in September 1948. It is now a major transport base with C-5s and C-17s under the Airlift Command. (WL.)

A crowd eager to see the giant Convair B-36 watched as this B-36A, 44-92019, arrived at San Francisco Airport on October 10, 1948, for the San Francisco Air Fair. It was placed with a Pan Am DC-4, United DC-6, TWA Lockheed 049, and a Martin Mars for close-up viewing. (WL.)

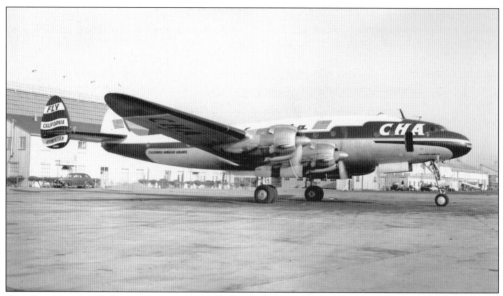

This Lockheed 049 Constellation, N74192, for California Hawaiian Airlines was painted in the same bright red, white, and blue colors used by California Central Airlines on their Martin 2-0-2s, which operated out of Oakland and San Francisco. It is running up in front of Hangar No. 3 at Oakland in February 1953. (WL.)

A Snow S-2C agricultural sprayer of Delta Dusters is shown at the small field in Brentwood in April 1964. The field also had a Weatherly, a Clark 2000, and a Stearman PT-17 ag plane, as well as private aircraft, such as the Fairchild 24R in the right background. (WL.)

Gladys Davis flies her Mooney M-18C Mite over downtown Concord in June 1950 on the way to the start of the Powder Puff Derby. She came in fifth in this annual women's cross-country race that went from California to South Carolina in 1950. (WL.)

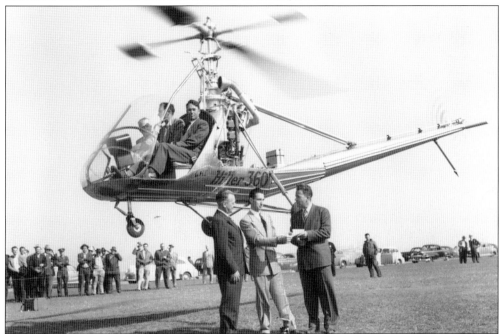

Designer and manufacturer Stanley Hiller Jr., in the middle foreground, is at a demonstration flight of one of his H-360 helicopters at his Palo Alto factory site. The helicopter evolved into the H-23 Raven and was bought in large numbers by the U.S. Army and served well in Vietnam as well as in other locations. (RC.)

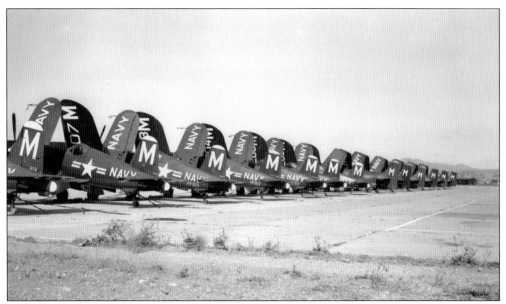

Vought F4U-4s of Fighter Squadron VF-63 line up at NAAS Santa Rosa in August 1951. VF-24 and two squadrons of Douglas ADs shared the field that year with the 144th Fighter Group of the California Air National Guard, during its two-week summer camp. (WL.)

Piper J-3C of the Santa Rosa Junior College School of Aviation is pictured on the old Santa Rosa Army Air Field in December 1947. The World War II control tower can be seen in the left background. The school also operated a Fairchild PT-26 and Cessna 120s. (WL.)

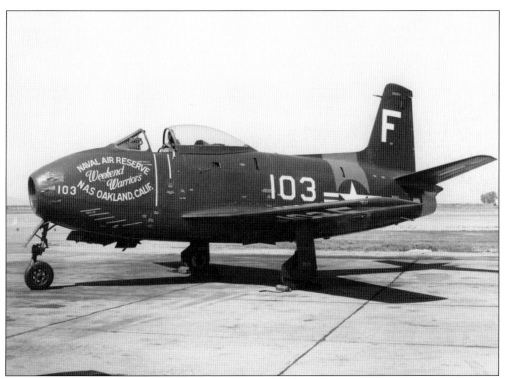

NAS Oakland was the first naval-reserve base in the United States to receive jet aircraft. The first of six North American FJ-1s was delivered in August 1949. They were soon proudly painted with their name, as shown in this photograph taken at Hamilton Field in 1950. (WL.)

The first operational combat unit to be based in the Bay Area with jets was the 84th Fighter Interceptor Squadron at Hamilton Field. They received new Republic F-84Ds, as shown in this April 1949 photograph. (WL.)

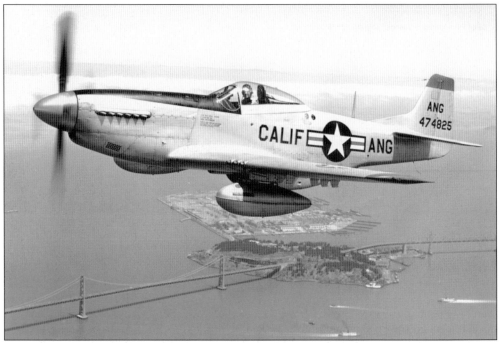

Brig. Gen. John Felton Turner, commanding officer of the 144th Fighter Wing, is seen here flying one of their F-51Ds over Yerba Buena with Treasure Island in the background. The drop tanks were added for this special posed photograph taken on June 24, 1951. (WL.)

The hangar built for the California Air National Guard at Hayward Airport is pictured with some of the F-51Ds of the 194th Fighter Squadron. This was also the headquarters for the 144th Fighter Wing, which included the 191st Fighter Squadron from Utah and the 192nd Fighter Squadron from Nevada. All three came together each summer for a two-week camp. (WL.)

This Skycoach Curtiss C-46F is typical of the many nonscheduled C-46s that operated in and out of Oakland in the early 1950s. Oakland Airport's large parking areas and overhaul facilities made it ideal for the large numbers of "non-sked" C-46s, DC-3s, and DC-4s. Some of the 53 C-46 operators seen at Oakland were AAXICO, Aero Coach, Air Cargo Express, All-American Airways, Associated Air Transport, Capitol Airways, Continental Charters, Meteor Air Transport, Modern Air Transport, Resort Air Lines, U.S. Airlines, and Westair Transport. (WL.)

An unusual sight at Buchanan Field in July 1961 was a fleet of four modified Naval Aircraft Factory N3N-3 and two Beech AT-11 firefighting air tankers. This photograph shows N3N-3 N7753C loading water from the fire hydrant at the base of the control tower. The planes made continuous 10-minute flights to the 2,500-acre fire on the southeastern slope of Mount Diablo. (WL.)

Orvis Nelson, founder and president of Transocean Air Lines, sits in the cockpit of one of his DC-4s at the airline headquarters in Oakland. A successful and innovative entrepreneur, Nelson, a former AAF and United Air Lines pilot, led Transocean to become the largest nonscheduled airline in the world after World War II. (RC.)

In 1950, Edward Joseph Daly purchased World Airways, which at the time consisted of two Curtiss C-46s. Daly moved his operation from New Jersey to Oakland and in 1956 was granted a Military Air Transport Service contract. In 1959, he obtained a Civil Aeronautics Board Supplemental Air Carrier certificate, which qualified him to obtain a military contract to carry military personnel and cargo. Daly retired as president in 1982 and died in 1984. (RC.)

A Sikorsky S-61N of the San Francisco–Oakland Airlines lands at the heliport at Lafayette in July 1968. SFO Airlines operated a fleet of Sikorskys around the bay. In addition to Oakland, San Francisco, and Concord Airports, a series of heliports were built at Emeryville, in downtown Oakland, the Ferry Building in San Francisco, and at Sausalito. (WL.)

One of the more unusual flights made in June 1972 was when SFO Airlines had the first marriage ever performed onboard a commercial helicopter. Mr. and Mrs. Jay Knepps are shown leaving the Sikorsky after being married over the Golden Gate Bridge. (LC.)

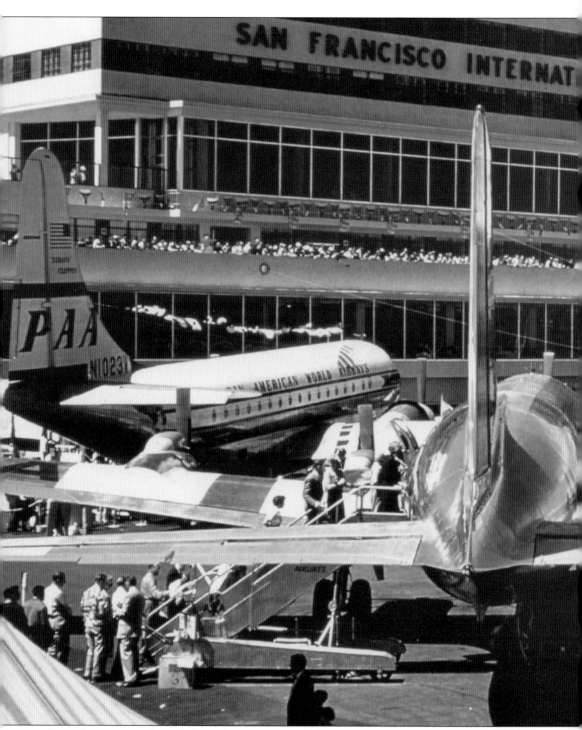

A new large terminal was dedicated on August 27, 1954, as part of a three-day public celebration. Some 500,000 people crowded the airport to tour the terminal and see 43 aircraft on display. Some planes—such as the Pan American World Airways Boeing 377, American Airlines Douglas DC-7C, Southwest Airlines Martin 2-0-2, and a United Airlines Convair 340—were

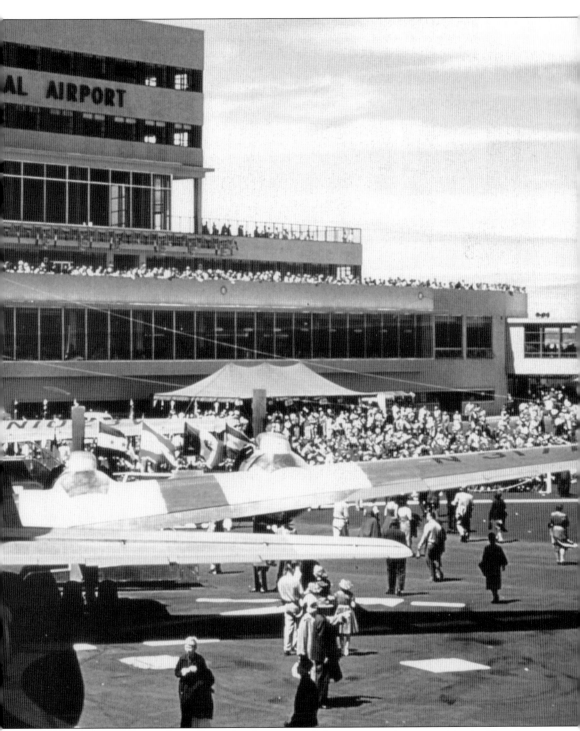

open, and long lines of people took advantage of the opportunity to see the inside of an airliner. A fine restaurant was on the level with the large windows, and below that, with all the people lined up, was the popular open-air observation deck. (WL.)

Ann Pellegreno's Lockheed 10A is shown in front of the old Oakland Airport Hotel on June 9, 1967, just prior to its takeoff to re-create Amelia Earhart's attempted 26,000-mile flight around the world at the equator. (WL.)

The successful flight returned to Oakland at 1:45 on the afternoon of July 7. Back in front of the old hotel, the crewmembers are, from left to right, William Polhemus (navigator), Ann Pellegreno, Leo Koepke (aircraft owner and mechanic), and Col. William Payne (copilot). (WL.)

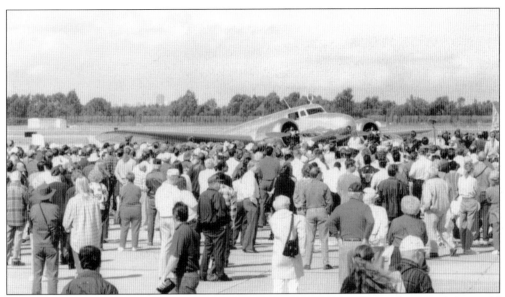

Thirty years later, Linda Finch and a series of navigator-copilots made another round-the-world flight in a Lockheed 10E to follow the proposed second route of Amelia Earhart's 1937 attempt. She left Oakland on March 17, 1997, and this photograph shows the crowd at Oakland Airport's North Field welcoming her back on May 28. (WL.)

Capt. Elgen Long, a longtime Flying Tigers airline pilot, stands in front of his Piper Navajo, *Crossroads Endeavor*, in which he flew solo around the world over the geographical north and south poles and equatorial poles and landed on seven continents. Long was a Bay Area resident, and the photograph was taken at SFO. (RC.)

The presidential helicopter, a U.S. Army Sikorsky at this time, arrives at Concord with Lyndon Johnson and staff on June 19, 1964. Two other helicopters with the Secret Service and staff are coming in behind to land in an open field south of the downtown area. The president arrived to dedicate BART, the new Bay Area Rapid Transit rail service, at the location for the Concord maintenance shops. (WL.)

This photograph provides a dramatic view of a Marine Corps–reserve helicopter taking off from Treasure Island with the San Francisco–Bay Bridge in the background. The demonstration flight by the Sikorsky CH-53A of HMH-769 from NAS Alameda took place on May 18, 1975. (WL.)

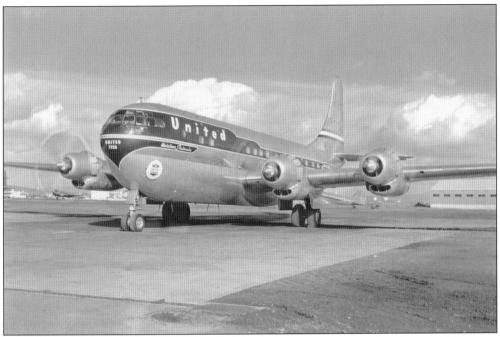

United Air Lines Boeing 377 Mainliner *Stratocruiser* runs up its engines in the United Maintenance Base area on the north end of San Francisco Airport. Both United and Pan American flew Boeing 377s to Hawaii from San Francisco. (WL.)

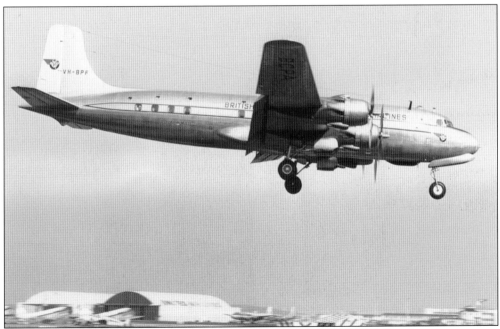

Douglas DC-6, VH-BPF, of British Commonwealth Pacific Airlines, lands at San Francisco on January 28, 1952. BCPA had the VH-BPH on exhibit at the airport in October 1949. Air travel to the Pacific was now available from several airlines, and all service was now being done with land-based aircraft. (WL.)

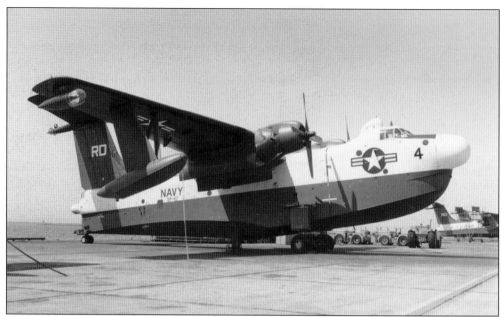

The last flying boat squadron to be based at NAS Alameda, VP-47, left in August 1960. Both VP-47 and VP-48 at Alameda were equipped with this Martin P5M-2. This photograph was taken on August 20, 1960, four days before they were to leave. (WL.)

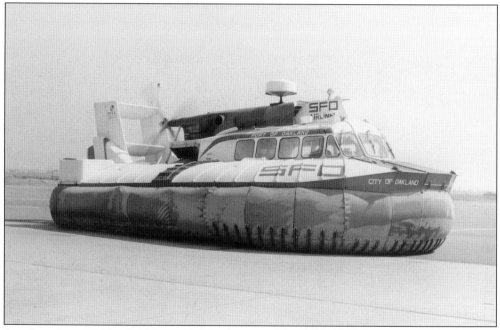

San Francisco–Oakland Airlines tested a hovercraft in 1965–1966 for proposed service from Oakland to San Francisco across the bay with a Westland SR-N5 built by Bell Aerosystems. This first test in the nation was funded by a federal grant and operated jointly by the Port of Oakland and SFO Airlines. During this period, they carried about 13,600 passengers, but after evaluation, the project was abandoned. Three hovercrafts of the same design were transferred from the U.S. Navy to the Coast Guard, and No. 3 was tested on San Francisco Bay in January 1971. (WL.)

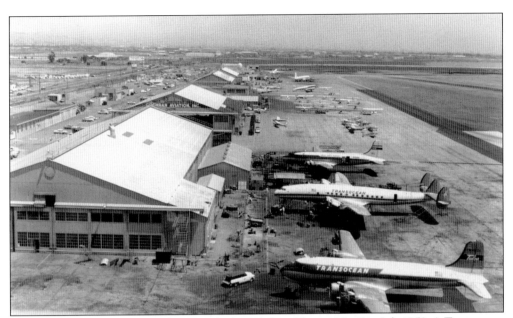

A rare historic view of Oakland Airport looks east from Hangar No. 5 in July 1958. A Transocean DC-4 and Constellation are in the immediate foreground, as well as a U.S. Overseas DC-4. Further past the group of Cessnas and a Bonanza is a United Air Lines DC-3 and DC-6. (DO.)

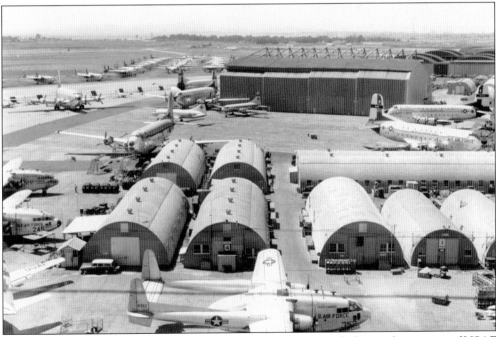

Looking west from Hangar No. 5 on the same date, this photograph shows a large group of USAF planes in for contract overhaul by Aircraft Engineering and Maintenance Company. The Fairchild C-119 in the foreground is just one of the large group of the same in the distance, while the center area shows Douglas C-124s and two Convair C-131s. (DO.)

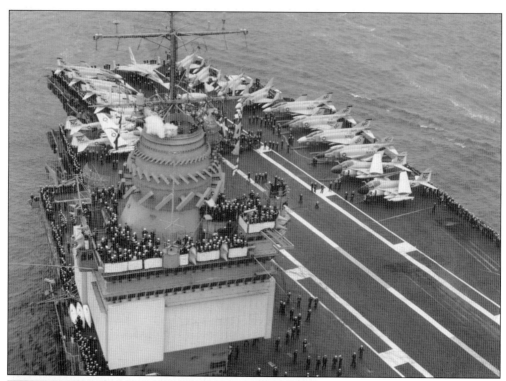

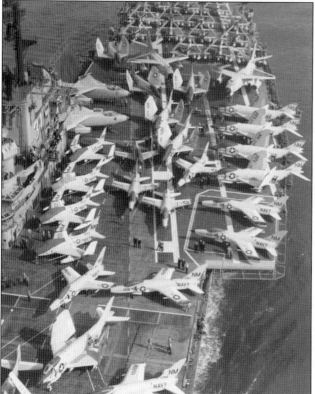

This is an unusual photograph of the USS *Enterprise* CVA (N)-65. The sailors around the island are welcomed by the Golden Gate Bridge as they return to NAS Alameda from a second combat tour of Vietnam on July 6, 1967. (WL.)

The USS *Bon Homme Richard* CVA-31 enters the Golden Gate on November 1, 1958, with Air Group 19 aboard, consisting of ADs, FJ-4s, F3Hs, and F11Fs. In the postwar era, NAS Alameda was homeport to the *Coral Sea*, *Hancock*, *Midway*, *Ranger*, and *Enterprise*. (WL.)

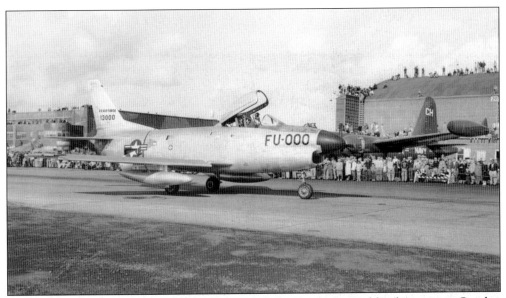

A North American F-86D moves slowly by part of a large crowd at Oakland Airport in October 1953. The public air show brought out thousands of people, and some of them can be seen lining the taxiway and on top of the hangars. The 1958 Oakland Air Fair had 400,000 people come to see the Blue Angels and 16 military aircraft on display. (WL.)

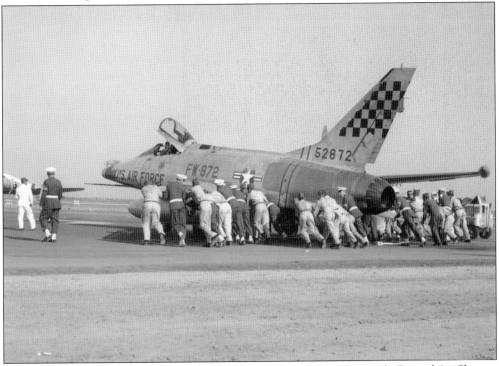

This photograph documents a rare and unusual sight. At the end of the Pacific Festival Air Show at SFO in September 1960, there were not enough tugs to move all of the aircraft preparing to leave. The result here with a North American F-100D was to round up every available man, including CAP cadets, to push the plane to the center of a taxiway for an engine start. (WL.)

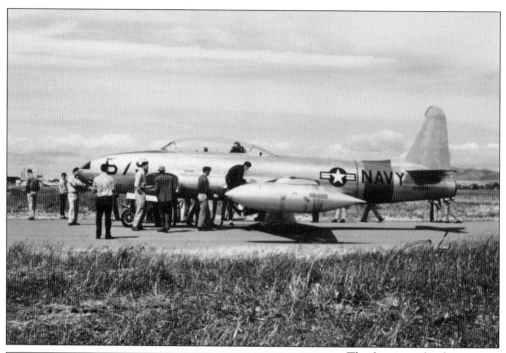

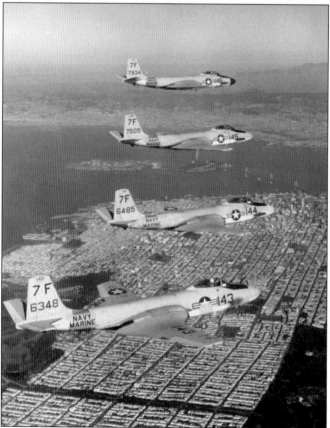

The first jet to land at Buchanan Field in Concord was this Navy Lockheed TO-2, the two-place trainer version of the P-80 fighter. The surprise event was the result of an emergency landing on May 12, 1951, by Lt. (jg) Dell Nardberg. It was joined in about 30 minutes by a Grumman F9F-2. After jet fuel was trucked from Moffett Field, the plane made an uneventful takeoff from the 5,000-foot runway. (WL.)

By 1958, the U.S. Navy and Marine Corps reserve squadrons at NAS Oakland (Tail Code 7F) were flying the McDonnell F2H-3. This beautiful navy photograph shows four F2H-3s flying over San Francisco with Treasure Island and Oakland in the background. (LC.)

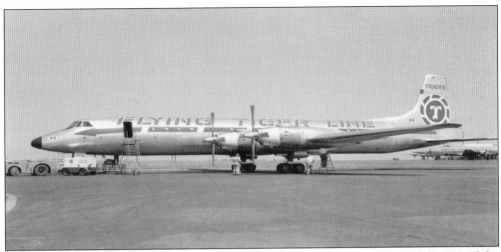

The turboprop era arrived in the late 1950s with airliners and corporate aircraft. One of the more remarkable types was this Canadair CL-44 of the Flying Tiger Line that had a swing tail for loading cargo. N451T, shown here at San Francisco in July 1961, is a tribute to the postwar veterans who began buying surplus C-47s to create various airlines. CL-44s of Airlift and Seaboard World Airlines also operated from SFO. (WL.)

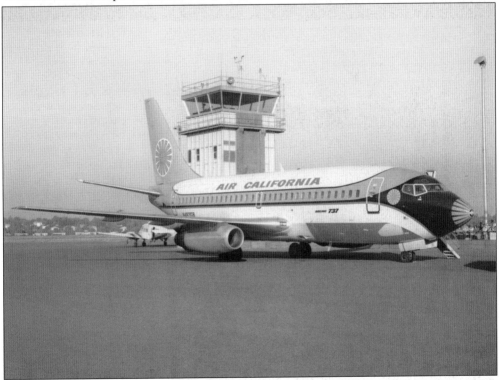

Air California's Boeing 737 flew into Buchanan Field, Concord, on October 26, 1968, with a large group rallying for Nixon for president. This was the first 737 to land at Concord, but there have been other political visits. Eugene McCarthy and Robert Kennedy also came in 1968, and Hubert Humphrey's private Convair 500 turboprop arrived in June 1972. Ted Kennedy came in a Lockheed 188 Electra in September 1974. (WL.)

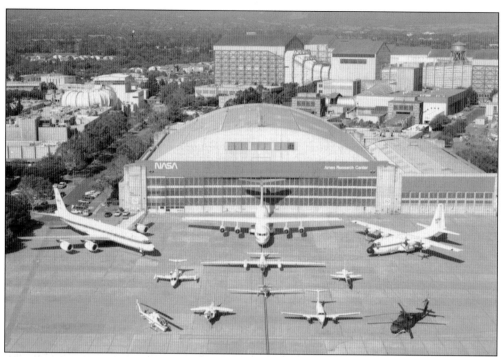

The Ames Laboratory of NACA and NASA has provided research results for years at Moffett Field. This view shows the aircraft hangars in the foreground and the large wind tunnels in the background. (NASA.)

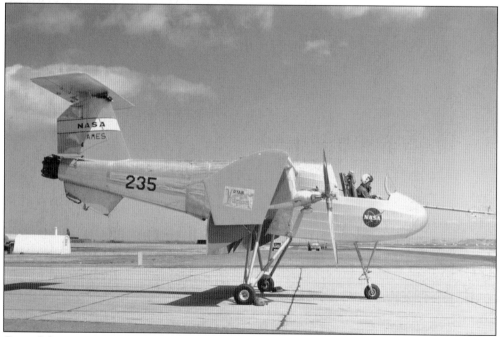

One of the more interesting experimental aircraft tested at NASA Ames was this Ryan XZV-3RY Vertiplane (USAF 56-6941), designed for vertical takeoff and landing. NASA test pilot Ron Gerdes is posing in the cockpit for assembled photographers on May 23, 1962. (WL.)

This photograph exemplifies the strong interest in aviation history in the Bay Area. It shows pioneer pilot Bobbie Trout and historian Carol Osborne making an oral-history tape of early pilot Walter Addems (License No. 965). It is taking place at James Nissen's private strip, "Meadowlark Field," at Livermore with his Curtiss Jenny in the background. This field was the site of several meetings of the Cross and Cockade World War I Society, who met to watch a Sopwith Pup, Thomas-Morse S-4C, Nieuport XI, and SPAD XIII fly. Other groups in the area have been the OX5 Aviation Pioneers, the American Aviation Historical Society, the Redwood Empire Aviation Historical Society, and the Society for Aviation History. (WL.)

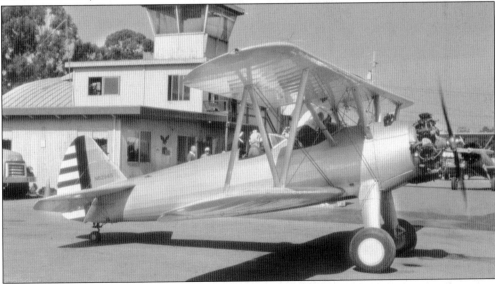

The Sonoma Valley Airport, better known locally as the "Schellville Aerodrome," is the center for antique and classic aircraft flying in Northern California. The Bay Area also has the Hiller Aviation Museum, Pacific Coast Air Museum, Travis Air Museum, USS *Hornet*, Western Aerospace Museum, and Wings of History with aircraft on exhibit. Smaller aviation museums are at Hamilton Field, Moffett Field, Alameda Point, and at the SFO International Terminal. (WL.)

ACROSS AMERICA, PEOPLE ARE DISCOVERING
SOMETHING WONDERFUL. *THEIR HERITAGE.*

Arcadia Publishing is the leading local history publisher in the United States. With more than 3,000 titles in print and hundreds of new titles released every year, Arcadia has extensive specialized experience chronicling the history of communities and celebrating America's hidden stories, bringing to life the people, places, and events from the past. To discover the history of other communities across the nation, please visit:

www.arcadiapublishing.com

Customized search tools allow you to find regional history books about the town where you grew up, the cities where your friends and family live, the town where your parents met, or even that retirement spot you've been dreaming about.

WITHDRAWN